IMAGES
of America

HARRISONVILLE

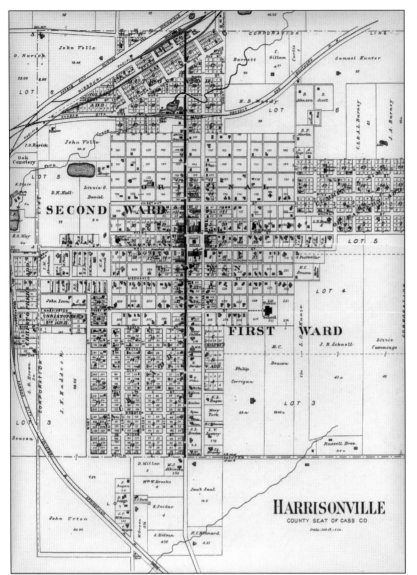

This 1895 plat of Harrisonville indicates how the town has grown from the original four streets that surround the square: Pearl, Wall, Lexington, and Independence. It was served by four railroads, which provided the most efficient transportation before the age of automobiles.

ON THE COVER: CASS COUNTY COURTHOUSE, 1940S. The Harrisonville Courthouse Square Historic District is on the National Register of Historic Places and is noted for its significance in commerce, architecture, and government from 1880 to 1943. The courthouse was finished in 1897. The retaining wall was built in the 1930s as a Civil Works Administration project with limestone from the Bird Quarry just north of Atkinson Funeral Home.

IMAGES
of America

HARRISONVILLE

Carol Bohl and David R. Atkinson

ARCADIA
PUBLISHING

Published by Arcadia Publishing
Charleston, South Carolina

Printed in the United States of America

Library of Congress Control Number: 2012941056

For all general information, please contact Arcadia Publishing:
Telephone 843-853-2070
Fax 843-853-0044
E-mail sales@arcadiapublishing.com
For customer service and orders:
Toll-Free 1-888-313-2665

Visit us on the Internet at www.arcadiapublishing.com

*Dedicated to all who contributed photographs and
memories of Harrisonville to capture and record what
made life special to those living and working here*

CONTENTS

ACKNOWLEDGMENTS

This book was written in honor of the 2012 celebration of the 175th anniversary of the creation of Harrisonville in 1837. The first lots in the city were sold that April, making this one of the oldest towns in western Missouri. Few people in 2012 can imagine the struggles of early pioneer settlers or the devastation the Civil War brought to this area. We seek to honor and remember the lives and stories of those who made Harrisonville the special hometown that it is today.

This book is not meant to be a comprehensive history of Harrisonville, Missouri. Instead, the authors sought to discover previously unpublished photographs to add another dimension to its history. Working with available photographs, we sought to highlight the stories of residents who worked, laughed, and played in this unique corner of the world.

The authors wish to thank each and every individual who shared photographs and memories. It was a joy and a privilege to help bring their stories and photographs of times gone by to the general public and to future generations.

Both authors share a love of postcards and local history and collaborated to share their postcard and photograph collections for this book. In addition, the Cass County Historical Society's (CCHS) photograph archives were used extensively. The society gave permission to use all the photographs not otherwise noted. A special thanks goes to the staff at Cass County Historical Society for use of their archives and facilities.

Many thanks to these local citizens who scoured scrapbooks and photograph collections to share photographs and details: Mary Doris Davis, Karen Carrel, Theron Swigart, Nancy and Walter Bruens, Salvatore and Tootie Scavuzzo, Carol Bailey Price, Willa Russell Dillon, Wendell Yeager, April McLaughlin, Julie McClain Cooper, Doris Hines, Sonya Grosshart, Rebecca Young Marquardt, Doris Riggs, Bennie Rice, Bruce and Gary Nyman, Jan Harper, Louise Cobb, Bill Mills, Mary Kathryn Yoder, Noel Floyd, Mike Peak, Allan Bird, John Collings, Jean Snider, Cass Regional Medical Center, Janet Allbaugh, and Clara Hoke.

INTRODUCTION

Harrisonville, Missouri, the county seat of Cass County, sits on the western border of Missouri some 30 miles south of the Missouri River, and is one of the oldest towns in western Missouri. For almost 150 years, from its 1837 beginnings until the 1980s, it served as the center of government, commerce, and cultural life in the county.

When the land opened up to settlement in 1825, pioneers, mainly from Virginia, Tennessee, and Kentucky, traveled west to seek opportunities for a better life. Development was steady and prosperous until its geographic situation and national politics combined in the 1850s to place residents in peril of their life and property. Raiding and bloodshed brought on by the struggle in Kansas between Free-Staters and Pro-Slavers—prompted by the passage of the Kansas Nebraska Act in 1854—spilled across the border into Cass County.

The Civil War only escalated the violent raids from Union Jayhawks and Redlegs and Southern guerrilla bushwhackers. The culmination came in 1863 with the disastrous edict of Order No. 11, which authorized the burning of crops, homes, fences, and outbuildings throughout the county and the forced dispersal and exile of all but some 700 of the county's residents. The county became known as the Burnt District due to the complete devastation.

Harrisonville residents Cole and Jim Younger joined with Southern partisans during the war, and after it ended, they joined with Frank and Jesse James and their other brothers, John and Bob Younger, to follow an outlaw life. The Youngers attended school in Harrisonville with Carrie Moore, who later gained worldwide fame as the hatchet-wielding prohibitionist Carrie Nation.

Harrisonville itself was not burned, but many residents never returned after the war. By the 1870s, recovery was in full swing. New families from northern states like Illinois, Ohio, and Pennsylvania poured into the county, coming on the four newly built railroads that crisscrossed the county immediately following the war.

Three local officials took part in issuing fraudulent railroad bonds, which led vigilantes to pull them from a train near Gunn City in 1872 and execute them. The "Bloody Bonds" are still framed in the 1897 courthouse on the Harrisonville Square. The words "A Public Office Is A Public Trust" are engraved above the south entrance of the courthouse to remind citizens to remain vigilant in demanding integrity from officeholders.

Following the war, new businessmen swarmed in from the east. Andrew G. Deacon, a Civil War veteran who lost his arm at Gettysburg, arrived from New York. He took the train to Pleasant Hill in 1866 and walked to Harrisonville with what he could carry. He and his brothers built prosperous dry goods stores in Harrisonville and the surrounding area. He built the first brick building on the Harrisonville Square in 1880 from sun-dried bricks made at a brick plant on the western edge of Harrisonville. Deacon Hardware was a family business on the square until 1965.

The Harrisonville Courthouse Square Historic District was placed on the National Register of Historic Places in 1994. It is anchored by the county courthouse, built in 1897. The three-story yellow brick structure is Italianate in style and was designed by the prestigious firm of W.C. Root.

The brick buildings on each side of the square were built from the 1880s through the 1920s. This central business district was the center of activity in the county for more than 100 years.

The square attracted lawyers, real estate agents, and businesses of all types. There were bankers, grocers, lawyers, dentists, and druggists on each side of the square from the 1880s all the way through the 1940s. Businesses such as Kunze Jewelry, Volle's Bakery, Allen Bank, and P.K. Glenn Drug Store were operated by two and three generations of a family. Harrisonville's fraternal and church groups as well as school activities offered residents cultural and social opportunities. White's Concert Band provided free concerts on the square for decades. Resident Brutus Hamilton brought fame and excitement to town when he captured the silver medal in the decathlon in the 1922 Olympic Games and celebrated in Hotel Harrisonville.

With the advent of paved roads in the late 1920s, the town became a mecca for both business and entertainment. The Jefferson Highway ran through the heart of Harrisonville as it wound its way from New Orleans to Winnipeg, Canada. Upwards of 10,000 people attended picnics, horse shows, and ball games at Davis Brothers Park and the County Fairgrounds. Chautauquas, vaudeville troupes, and newfangled picture shows drew crowds to the square. County residents flocked there on Saturdays and spent the day conducting all their business and socializing. Stores would stay open until midnight to serve the last customer.

Businesses began moving from the central district to the west edge of town in the 1970s with the arrival of the big box stores and the new dual-lane Highway 71. Culture wars took a toll on the square in 1972, when two police officers and an innocent bystander were killed by a counterculture leader who then took his own life. The ensuing struggle to mediate the deep divides between generations and races forced the community to deal with similar issues swirling across the nation.

A fire in 1983 consumed the 100-year-old Hotel Harrisonville, leaving an empty lot on the square for the first time since the Civil War. But the surviving buildings are distinguished for their architecture and offer visitors a true slice of what small-town America looked like for generations.

This book offers unique, previously unpublished photographs and a look behind the scenes of life on the square and around Harrisonville.

One

IN THE BEGINNING

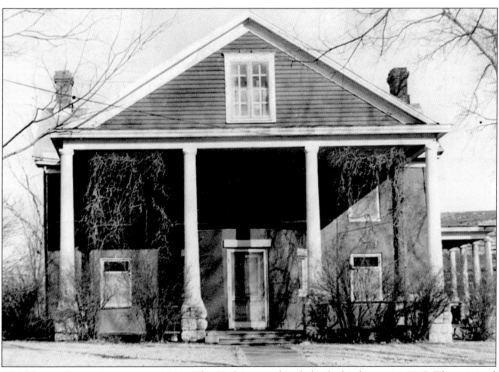

105 NORTH PRICE AVENUE, C. 1910. The Tarkington family built this house in 1847. The original four rooms have 18-inch-thick brick walls. Cuthbert Mockbee bought the house in 1859, and it was the site of a fight between Union officer Irvin Walley and Harrisonville resident Cole Younger at a dance in 1861. In 1900, the John Davis family extensively remodeled the home, which still stands on its original site.

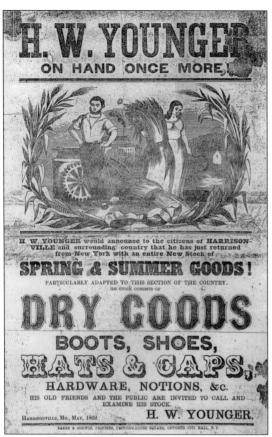

ADVERTISEMENT, 1862. Henry Younger owned and operated a store and livery on the Harrisonville Square from 1858 to 1862 and was mayor in 1859. This May 1862 advertisement indicates that he restocked after a July 1861 robbery by Jennison's Kansas Jayhawks. Younger was murdered in 1862 by federal troops near Kansas City. After the war, his sons Cole, Jim, John, and Bob joined Jesse and Frank James to rob banks and trains.

YOUNGER FARM BARN, 1907. The stone barn below stood on property once owned by Henry Younger on the south side of Orient Cemetery Road south of Orient Cemetery. The Younger home was burned in 1863 as a result of Order No. 11 because it was not inside the city limits. The boy seen here is Paul Hanes, whose family lived on the land in 1907. The barn no longer exists.

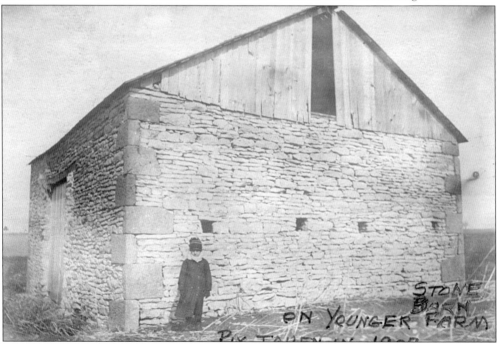

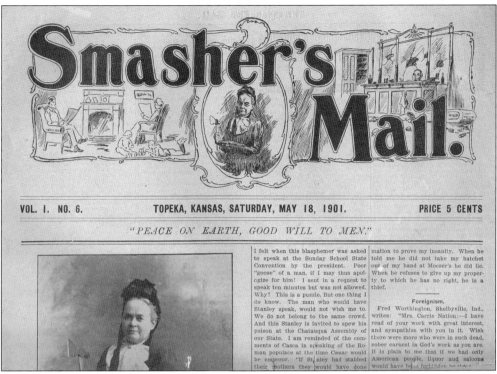

Smasher's Mail.

VOL. I. NO. 6. TOPEKA, KANSAS, SATURDAY, MAY 18, 1901. PRICE 5 CENTS

"PEACE ON EARTH, GOOD WILL TO MEN."

I felt when this blasphemer was asked to speak at the Sunday School State Convention by the president. Poor "goose" of a man, if I may thus apologize for him! I sent in a request to speak ten minutes but was not allowed. Why? This is a puzzle. But one thing I do know. The man who would have Stanley speak, would not wish me to. We do not belong to the same crowd. And this Stanley is invited to spew his poison at the Chatauqua Assembly of our State. I am reminded of the comments of Casca in speaking of the Roman populace at the time Cæsar would be emperor. "If Stanley had stabbed their mothers they would have done mation to prove my insanity. When he told me he did not take my hatchet out of my hand at Moeser's he did lie. When he refuses to give up my property to which he has no right, he is a thief.

Foreignism.

Fred Worthington, Shelbyville, Ind., writes: "Mrs. Carrie Nation:—I have read of your work with great interest, and sympathize with you in it. Wish there were more who were in such dead, sober earnest in God's work as you are. It is plain to me that if we had only American people, liquor and saloons would have been forbidden by the

CARRY A. NATION, 1901. Carry Amelia Moore came with her family from Kentucky to Cass County in 1854, settling several miles northwest of Harrisonville. She attended school with Harrisonville resident Cole Younger. Nation rose to international prominence when she campaigned against the evils of drink from 1899 to 1907. She is buried in the Belton, Missouri, cemetery alongside her parents. She published *Smasher's Mail* to publicize her efforts.

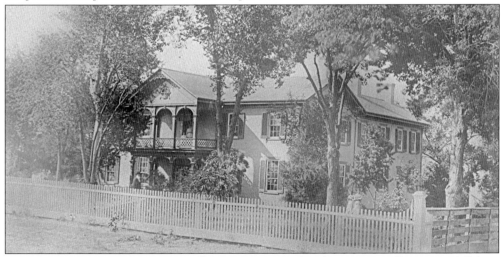

BROWN RESIDENCE, 1880s. Robert Allison Brown arrived in the Harrisonville area in 1842 from Tennessee and established a thriving farm, a grist and sawmill, a school, and a Methodist church three miles northwest of town. This home was completed by 1850 and was made with bricks created on-site. It is on the National Register of Historic Places and is still owned by a member of the original Brown family. Brown exerted much influence on Harrisonville's development.

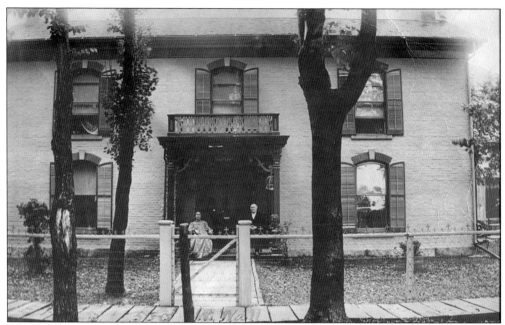

300 WEST WALL STREET, 1910. Built in 1852 by businessman Abram Cassell, this house served as a hospital during the Civil War and later served as a school. Dr. Thomas Beattie, seen here with his wife, Martha Stuart Byers, lived and practiced medicine here from 1874 to 1917. Edward Kennedy, who owned the house from 1917 to 1926, operated a steam laundry in Harrisonville. Walter Benn lived here from 1926 to 1969, when present owners Ray and Connie White purchased it.

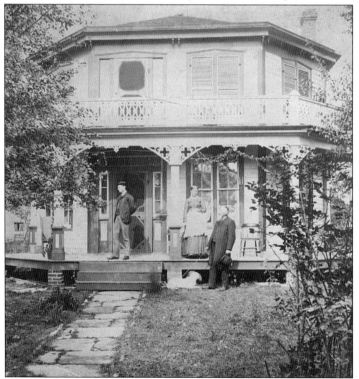

702 WEST WALL STREET, C. 1900. Abner H. Deane stands in front of the octagonal house he built in 1867, which still stands. Deane served as a Union major in the Civil War but was imprisoned in 1866 in Independence for refusing to take the Ironclad Loyalty Oath demanded of anyone in Missouri who wanted to preach, teach, hold public office, or vote. George Caleb Bingham painted Deane's picture while he was in jail.

12

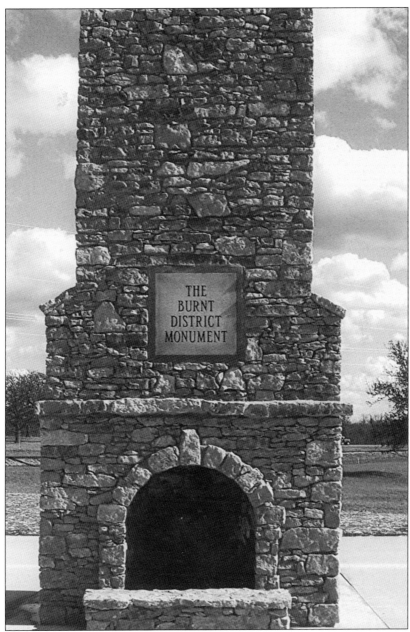

BURNT DISTRICT MONUMENT, 2501 WEST WALL STREET. This monument stands on the front lawn of the Cass County Justice Center in Harrisonville and honors the memory of the women, children, elderly, and civilians who bore the brunt of the fury of the Civil War in the counties of Jackson, Cass, Bates, and Vernon—an area that came to be known as the Burnt District. After Order No. 11 mandated the exodus of some 30,000 citizens from those counties, all homes, crops, and fields were burned, leaving only charred stone chimneys standing. Historian Albert Castel wrote of Order No. 11, "It stands as the harshest treatment ever imposed on United States citizens under the plea of military necessity in our nation's history." Plants surrounding the monument are all native prairie grasses, flowers, and trees. The stones, native limestone from the Henry Younger farm, were hand cut by local masons Jerry and Jarold Saling.

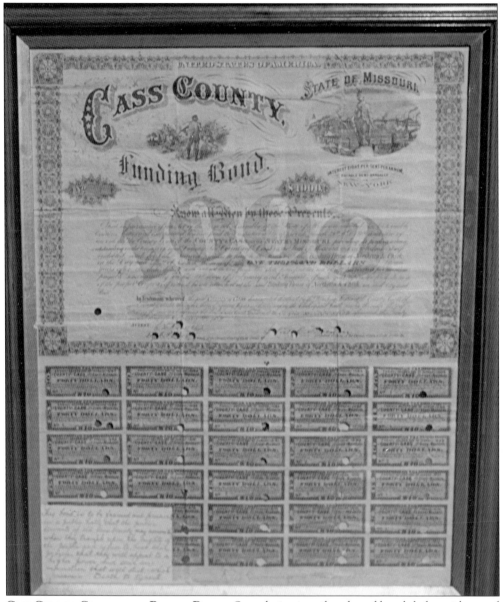

CASS COUNTY COURTHOUSE BLOODY BONDS. Speculation in railroads and bonds led to widespread corruption in western Missouri in the early 1870s. Three men were murdered by citizens in Cass County's Gunn City in April 1872 for their part in issuing fraudulent bonds that put the county in debt for four decades. An 1878 Harrisonville ordinance requires the following: "This bond is to be framed and preserved in a public hall, that the public servants of old Cass County may remember when they trampled upon the rights of the people, and refused to hear their prayers, that they will appeal to a higher power and serve an injunction that will stick—which means—DEATH TO THE TYRANTS!" An inscription on the southwest corner of the 1897 courthouse refers to the county judges who served prison time rather than collect taxes from Cass County citizens for what the judges determined were fraudulent railroad bonds issued in the 1870s. The tablet and inscription above the south entrance, "A Public Office Is a Public Trust," reminds citizens of the burdens imposed by unethical county officials.

14

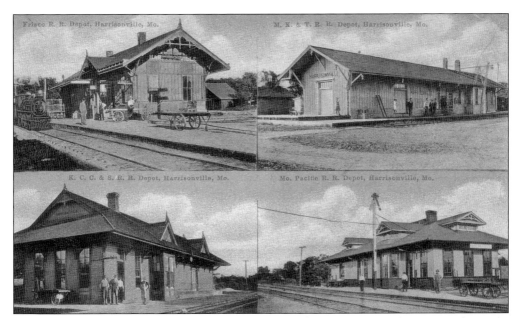

HARRISONVILLE DEPOTS, 1908. Although none remain, Harrisonville had four train depots for decades. In the upper left is the Frisco depot, at 713 North Independence Street, north of the old electric building. In the upper right is the Missouri, Kansas & Texas (KATY) depot, at 1301 North Independence Street. The Kansas City, Clinton & Springfield (Leaky Roof) depot, at 1101 West Mechanic Street, is in the lower left, and the Missouri Pacific Depot, at 1107 North Independence Street, is in the lower right.

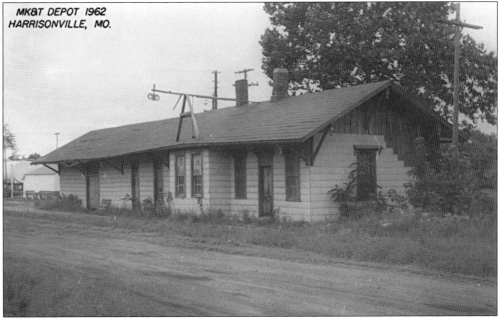

MK&T DEPOT, 1962. Known as the Katy, the Missouri, Kansas & Texas ran from east to west through the center of the county. The depot stood at 1301 North Independence Street for some 90 years before being demolished in 2001. It once served as a dispatcher's headquarters and carried passengers and freight leaving from Harrisonville.

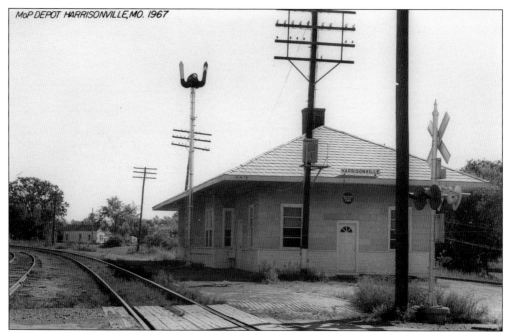

MISSOURI PACIFIC DEPOT, 1967. The MoPac line still runs through Harrisonville, skirting the north side of Harrisonville Lake and City Park and crossing North Independence Street at Shelton and Sons. The depot stood at 1107 North Independence Street.

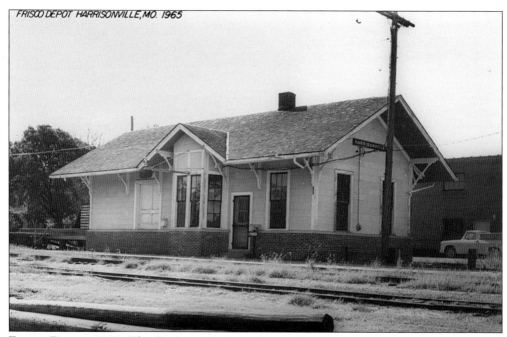

FRISCO DEPOT, 1965. The St. Louis & Santa Fe, or "Frisco," was the first railroad to serve Harrisonville, arriving in February 1871 from Holden. This depot was at 713 North Independence Street, near the site of the old electric building.

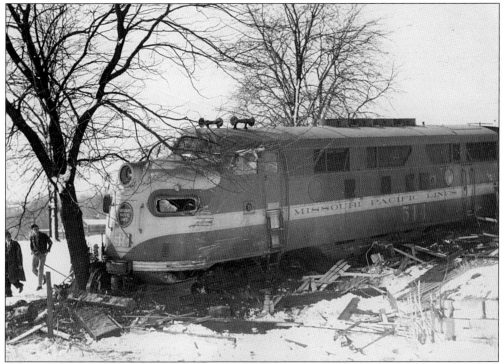

Missouri Pacific Wreck, 1949. This diesel engine of a three-engine train sideswiped a steam-driven train at about 25 miles an hour. It hit the tank car full of water, left the track, crashed into a section house, gathered a pile of steel fence posts, and pinned them against this large thorn tree, about 60 feet southeast of the main line just north of Lake Luna. (Photograph by Paul Pippitt.)

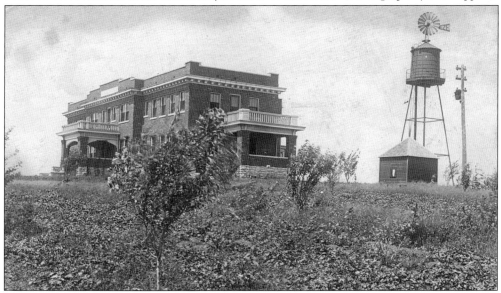

2001 Jefferson Parkway, 1910. In 1910, the county built the County Home, seen here, having sold the original 40-acre poor farm in 1909. Kansas City architect Walter Lovett designed 24 bedrooms, with a toilet and lavatory on each floor and steam heat, at a cost of $15,000. A well provided water via this water tower. Today, the site is part of the Golden Years complex.

FRANCIS XAVIER RUNNENBURGER, C. 1880. This businessman was born in Germany and arrived in Harrisonville soon after the Civil War, establishing a furniture store and funeral business in 1866. The furniture building on North Independence Street still stands in the 300 block. Family members operated the businesses for three generations. (Courtesy of Mike Peak.)

DR. ISAAC M. ABRAHAM, C. 1898. Dr. Abraham (below) stands in front of his house near 301 South Lexington Street, leaning on a tree he planted from a seed. He came to Harrisonville right after the Civil War, where he had served as a surgeon with an Ohio Union regiment. Belle Allen and Ida Elder Brouse are seen here leaving his home after a visit. Today, Cass County Publishing occupies the site.

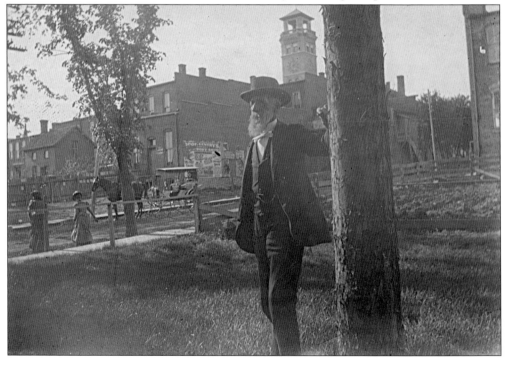

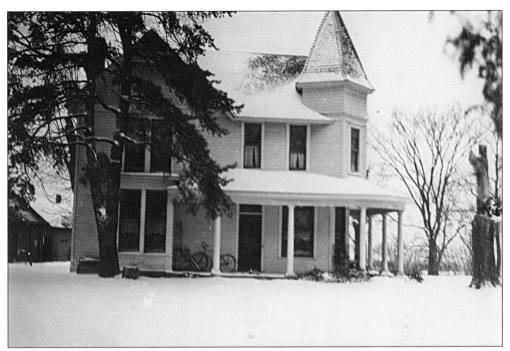

600 West Wall Street, c. 1910. This is the home of George Bird, the mayor of Harrisonville from 1890 to 1896. He was also county surveyor and the owner of Western Bridge Company. Bird pushed for better streets and sidewalks and the first municipal light plant. This building is now part of the Atkinson Funeral Home. (Courtesy of Allan Bird.)

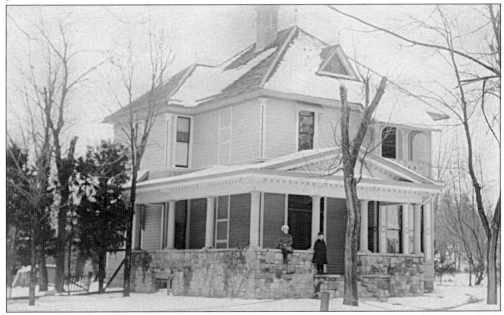

1004 Walnut Street, 1909. This still-standing Victorian Greek Revival-style house was built in 1889 by hardware magnate Andrew Deacon. Three years later, Deacon built the three-story building that still stands on the southeast corner of the square and now houses a law firm. By 1909, this was the home of the W.S. Byram family.

Dr. Scott and Dr. Triplett. These two doctors served Harrisonville for decades, making house calls day and night. Salvatore Scavuzzo remembered Dr. James Underwood Scott (left) coming to his house at 2:00 a.m. to give him a shot; he took apples for payment. Dr. Scott practiced in Harrisonville for more than 50 years after receiving his degree from Washington University in St. Louis. Dr. Jacob S. Triplett (below) is seen here in 1955 at his home office at 703 South Independence Street, where he still practiced at the age of 90. Triplett came to Harrisonville in 1892 with a medical degree from the University of Michigan and married Cass County native Pearle Bridges in 1899.

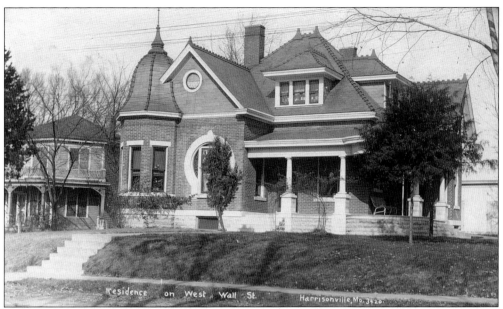

608 WEST WALL STREET, C. 1903. This house was built in 1888 with walls that were three bricks thick for Manwell Williams, the president of Allen Banking Company. It was designed and built by local architect Tip Ludlow using bricks from Coffeyville, Kansas, and stone from Carthage, Missouri. The original roof was slate and it served as the Catholic rectory from 1941 to 1974, when the sanctuary stood just to its east.

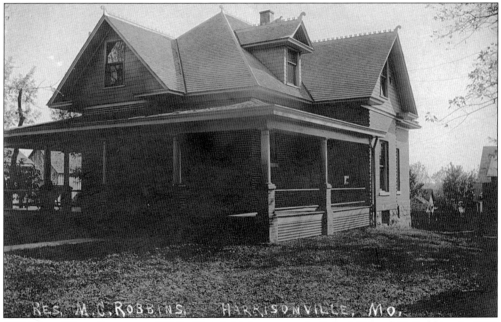

405 WEST WALL STREET, C. 1908. This brick home was built by Michael C. Robbins in 1907 on the site of the first brick home in Harrisonville, which was built in 1846 by John Cummins, a county judge. Robbins was a tinner and plumber who designed and manufactured pumps, windmills, and wagon end-gates while working for Deacon and Clemments Hardware for 45 years. This house still stands today.

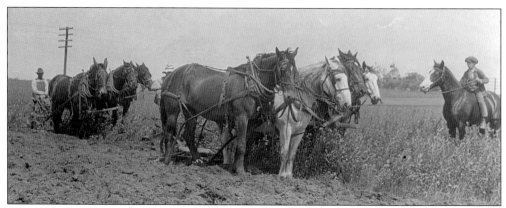

CASS COUNTY, 1930S. Farming with horses and mules was common in the county until the 1930s, when farmers began to mechanize. These men plow under sweet clover to prepare a corn field. Note the power lines in the distance; many areas of the county were not electrified until the late 1940s. Agriculture remains a strong component of Harrisonville and Cass County's economy.

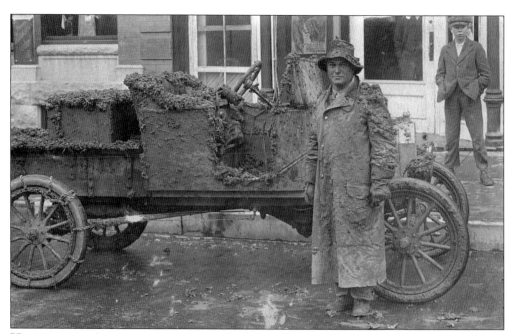

HARRISONVILLE SQUARE, C. 1915. Before the burgeoning use of automobiles, very few roads were paved. Drivers like Walter Brooks, seen here, had to battle the mud—note the chains on the tires. The square was paved with bricks in 1915 to accommodate cars and the need for paved, 365-day-a-year roads led to hard-surfaced roads and highways such as the Jefferson Highway.

JEFFERSON HIGHWAY BROCHURE, 1923. The Jefferson Highway ran from New Orleans to Winnipeg, Canada, from 1916 to 1926, when highways were given numerical names. It crossed the heart of Cass County and entered Harrisonville on what is now Orchard Road, hit Independence Street crossing the west side of the square, and went up Jefferson Parkway. The route through Harrisonville is marked today with signs similar to those originally used to guide drivers.

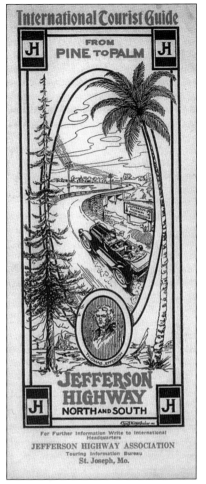

HIGHWAY 71, 1930s. Prosperity and lower-priced cars enabled many people to purchase their first vehicles in the 1920s. Drivers clamored for reliable paved roads as opposed to the typically rutted, muddy ones. Highway 71 was paved through Cass County in 1928–1929. Roadside amenities sprang up like gas stations, cafés, and tourist camps such as Davis Brothers Park (right). This view looks south from what is now South Commercial Street near Sonic.

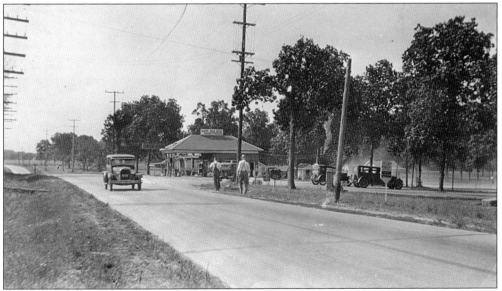

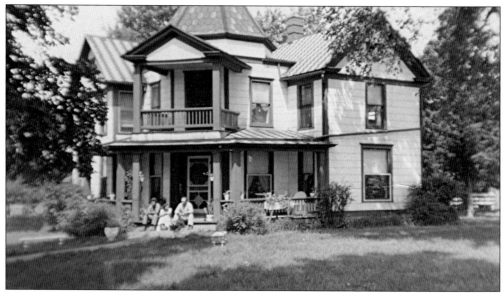

DAVIS/WELCH HOME, JEFFERSON PARKWAY. The home of Agnes Davis stood on property that is now part of the Harrisonville Community Center. Her son, Bill Davis, was the Harrisonville chief of police. The house was also lived in by the Welch family. The house and barn were disassembled in 2003 to make way for the Community Center. (Courtesy of Doris Anstine Russell.)

HENDERSON HOME, 1406 JEFFERSON PARKWAY. Between 1920 and 1925, educator and farm manager E.L. Henderson built this home of Carthage limestone in the Craftsman/Bungalow style. Local stonemason Jacob "Jake" Davis cut all the stone by hand. Davis also cut the stone for the Hight home on West Wall Street, which is now Spencer Hall, and several other homes in the 1920s. Today, it is owned by John Kiefer.

OAKLAND CEMETERY, 1984.
Wrought-iron gates were
repaired and reinstalled in 1984
at the entrance to Oakland
Cemetery on the east side
of Commercial Street. The
1923 gates had been badly
damaged, but a fundraising
campaign enabled local mason
Ray Carter to do the work. He
also reinforced the Carthage
limestone pillars. The
stone pillars and fence were
originally cut and assembled
by hand by Jake Davis.

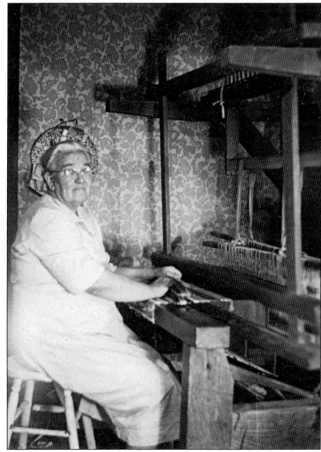

FRANCES KELLER, 1946. In
this photograph, Harrisonville
resident Frances Keller was 66
and still working her barn loom
to make rag rugs. The loom was
fashioned by Stine Keller from
locust trees growing on the
Keller property, between East
Lynne and Pitts Chapel. The
loom, now in the basement
of the Sharp-Hopper Log
Cabin, is in working condition.
This was the standard loom
design for centuries.

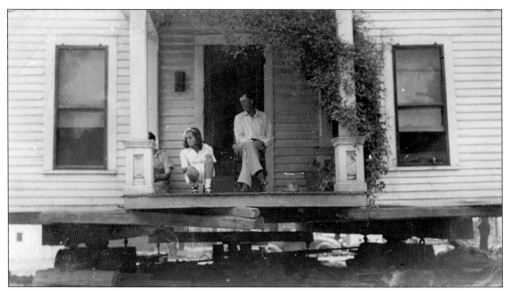

300 Block, South Lexington Street, 1948. This house, which sat where the Cass County Publishing office is today, was moved in 1948 to 202 South Halsey Avenue, where the two-story white house still stands. Sitting on the porch are Linda Mosely Cummins and John Neuenschwander. The house belonged to George E. and Elizabeth Cummins. (Courtesy of Sonya Grosshart.)

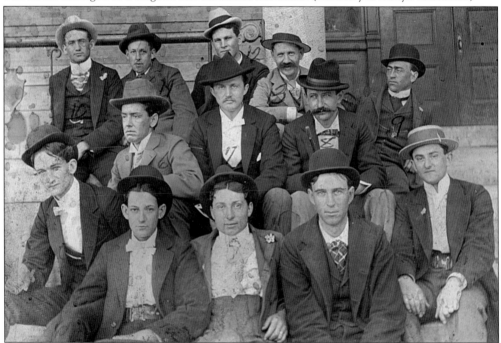

Jolly Good Fellows Club, 1911. A group of Harrisonville professionals, this club included, from left to right, (first row) Harlie Clark, newspaperman and postmaster; Harry McCullough, abstracts; Bismarck Burke, funeral director; and Edward Salinger, seller of men's clothing; (second row) Will C. Deacon, hardware store owner; Arthur Gwinn, lawyer; Dr. James Scott; Charles Hauk, cigarmaker; and J. Terrill, druggist; (third row) Melbourne Brocaw, newspaperman; R. Brown Daniel, assistant county clerk; George Corrigan; and "Rev" Moultin, furniture seller.

Two
SQUARE DEALINGS

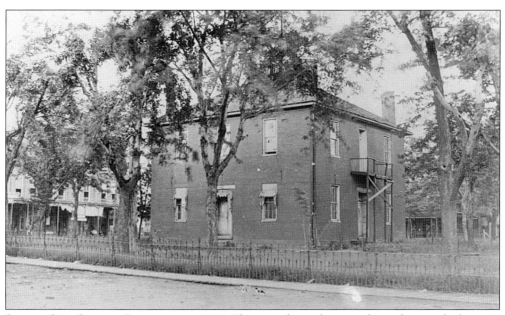

SECOND CASS COUNTY COURTHOUSE, 1896. This view shows the second courthouse, which was in use from 1844 to 1896, shortly before it was demolished to make way for a three-story replacement. The county had outgrown the space and conducted business in several buildings around the square. In the 1890s, the county was still seeking reimbursement from the federal government for the courthouse damages caused by occupying federal troops in the Civil War.

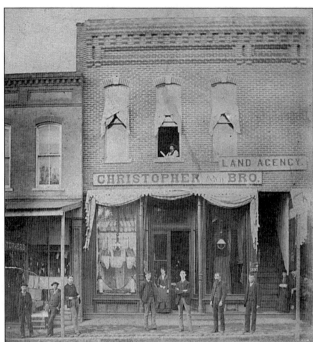

106 East Pearl Street, c. 1884. The Christopher brothers operated a dry goods, boots, and shoes business here from the 1880s to the early 1900s. An exact reproduction of the Brooklyn Bridge made of thread by L.W. Bryant is in the window. Later businesses in this space were Mallon's (1923–1964), Foster's Fabrics (1974–1979), Nancy's Hallmark (1980–1983), Angels' and Golden Classics Jewelry (1983–2002), Shelton's Printing (2003–2004), and Bower's Engineering (2006–2010).

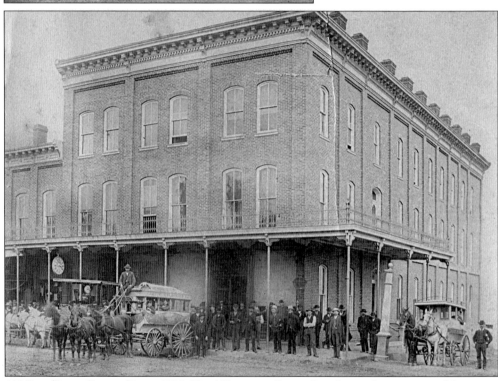

110 East Pearl Street, Built 1883. Hotel Harrisonville stood on the northeast corner of the square for 100 years. It was financed by a group of businessmen to replace a pre–Civil War hotel. The hotel was home to a variety of businesses through the years and served as the meeting place for civic clubs. A fire started in the kitchen in 1983 and destroyed the building. Only an empty lot remains.

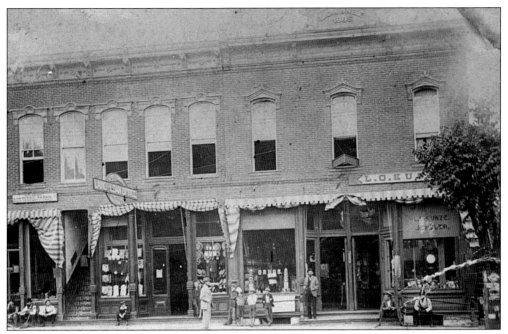

WEST SIDE SQUARE, 1896. Photographer J.C. Shinkle captured this photograph of businesses on the north end of the west side. From left to right, they are Scruggs and Clemment Hardware, The Hub Men's Wear run by the Salinger brothers, Schooley Drugs, and L.O. Kunze Jewelry. The second floors housed professionals such as doctors, dentists, lawyers, and realtors.

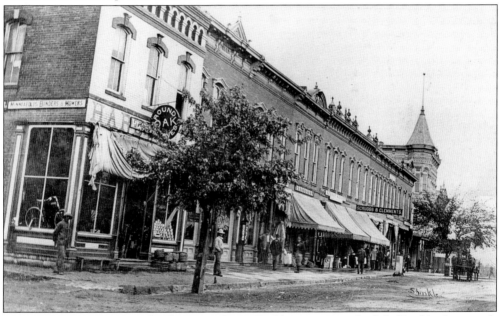

WEST SIDE SQUARE, 1896. The three-story Evans Building is seen in this J.C. Shinkle photograph before the fateful July 1900 fire reduced it to two stories. The other businesses are, from left to right, Deacon Hardware, the oldest building on the square, built in 1880; Volle Pioneer Bakery; Boardman Harness & Saddlery; grocery and clothing stores; and Kunze Jewelry. These buildings, constructed in the 1880s in Victorian and Italianate styles, still stand today.

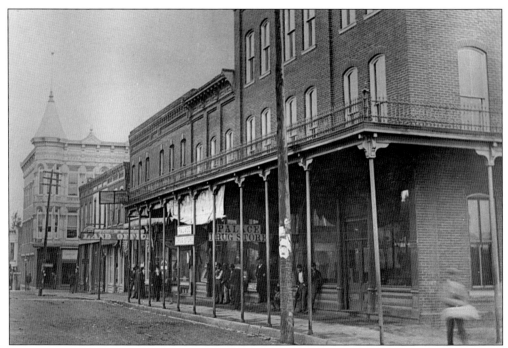

NORTH SIDE SQUARE, 1896. This J.C. Shinkle photograph shows the power poles for electricity, which was available in 1895 when the power plant came online. From left to right, the stores include Barrett's drugstore, Allen Bank, Annie Flora Millinery, Christopher Brothers, Hancock & Deane Books & Stationery, and the three-story Hotel Harrisonville. The three-story Evans Opera House stands on the northwest corner.

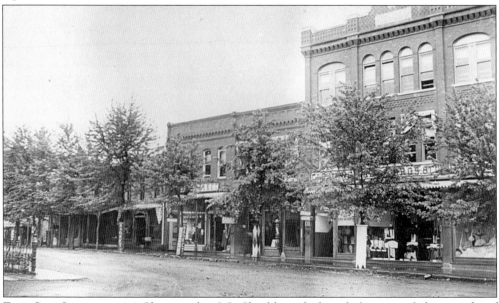

EAST SIDE SQUARE, 1896. Photographer J.C. Shinkle took this whole series of photographs of each side of the square. Note the trees lining the sidewalk and the wrought-iron fence around the second courthouse. These businesses are, from left to right, J.A. Harvey's Racket Variety Store, McConnaughay Barber and Taxidermist, and Hartzler Mercantile.

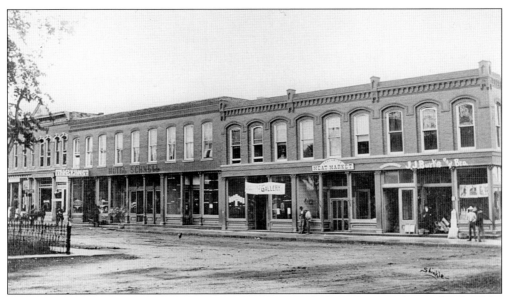

SOUTH SIDE SQUARE, 1896. In this J.C. Shinkle photograph, businesses on the south side of the square included, from left to right, a restaurant, Hotel Schnell, a gallery, Levi Smith Meat Market, and J.J. Burke and Bro. mercantile.

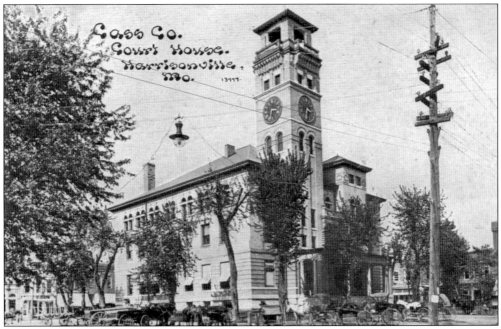

CASS COUNTY COURTHOUSE, BUILT 1897. This courthouse is Cass County's third. The first was a log building at 200 West Wall Street and the second was a two-story brick building that was on this site from 1844 to 1896. This Italianate building is the centerpiece of the Harrisonville Courthouse Square National Historic District and still houses county offices, although the courts have moved to the Justice Center on the west side of town.

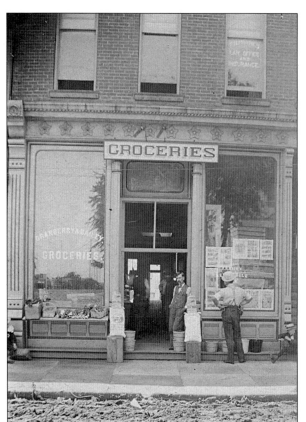

115 East Wall Street, c. 1895. Dunn and Granberry Grocery occupied this building, which is where the fire that destroyed the south side of the square started in February 1900. The second floor housed attorneys James S. Wooldridge and Thomas Haynes, who lost their annotated law library in the fire. The building erected here in 1901 later housed Cox's 5 and 10 Cent Store, McClain Brothers Electric, and clothing and thrift stores.

South Side Square, February 1900. The worst fire in Harrisonville history (below) totally destroyed the south side of the square in February 1900. By the end of 1902, the block was entirely rebuilt, and those new structures remain today. The fire started in the basement of the Dunn and Granberry Grocery store and spread beyond the capacity of firefighters.

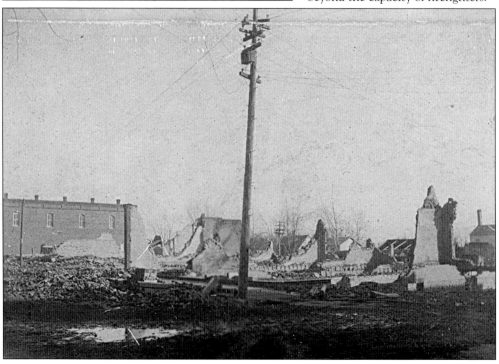

100 South Independence Street, c. 1900. This two-story brick Italianate building was completed in 1885 for Ludwig Oswald Kunze, a German immigrant who established a jewelry store here in 1857. His son, Polar Kunze, sold the business in 1957 to Bob Noe. The building housed Van's Flowers from 1964 to 1977 and then law offices. Ludwig Kunze stands to the right of the doorway (seventh from left), and his associate Will T. Price stands to his left in the doorway (sixth from left).

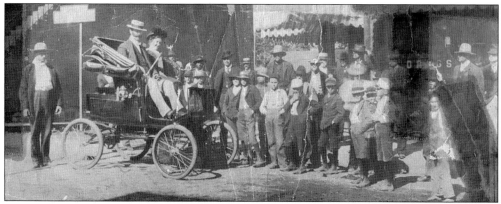

Harrisonville Square, 1905. The first automobiles in Harrisonville drew crowds of admirers on the square. This couple stopped at Flora's Drugs to purchase benzene for fuel, as there were no filling stations. For the next few years, local merchants tried to ban automobiles because they were afraid shoppers with horses, wagons, and buggies would be frightened and stop coming to town.

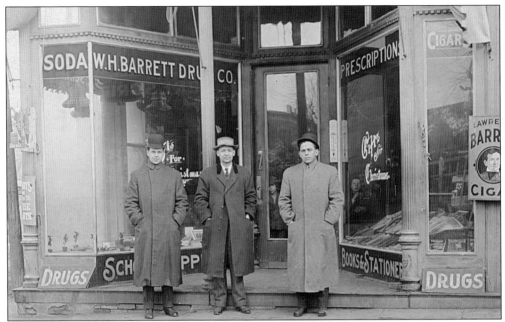

100 East Pearl Street, c. 1900. William H. Barrett established a drugstore in 1865 and built a brick building in 1871 on this site. Dr. James Scott, who had an office on the second floor, is seen here on the right. It became Bennett's Drug Store and then, in 1948, the Jack Bedsaul Pharmacy. The building was razed in 1958 to make way for the current Country Club Bank. (Courtesy of David Atkinson.)

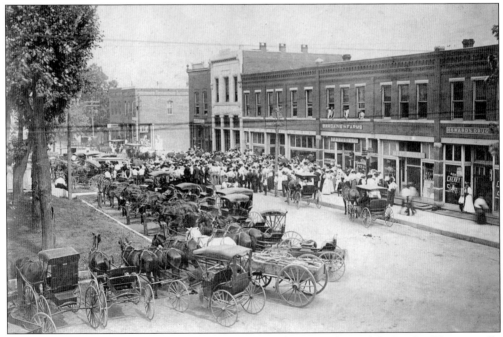

South Side Harrisonville Square, c. 1905. A special event in front of the Bank of Harrisonville building appears to have drawn a crowd. As only horses, buggies, and wagons are seen, this must have been before automobiles arrived in about 1905. (Courtesy of April McLaughlin.)

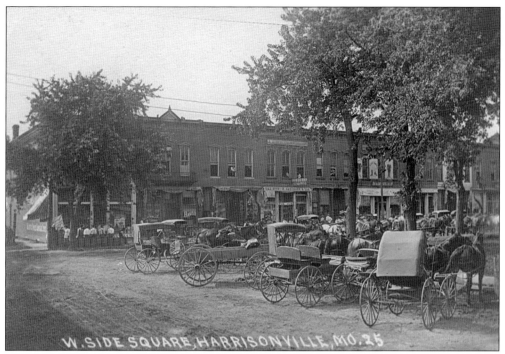

WEST SIDE SQUARE, 1908. This Ritchie Brothers postcard focuses on the buggies parked on the south side of the courthouse and the west side of the square. These businesses are, from left to right, Deacon Brothers Hardware, Volle's Bakery, Boardman Harness, Clatworthy Photography, and clothing and grocery stores.

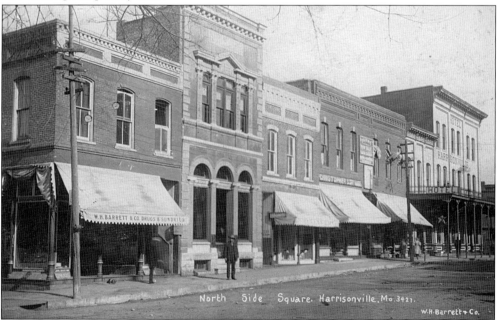

NORTH SIDE SQUARE, 1908. From left to right, pictured are Barrett's Drugs; Allen Bank, following its 1902 third-story addition; Annie Flora's Millinery Bazaar, Christopher Brothers Dry Goods, Boots, and Shoes; Pearson's Grocery; and Hotel Harrisonville. (Courtesy of David Atkinson.)

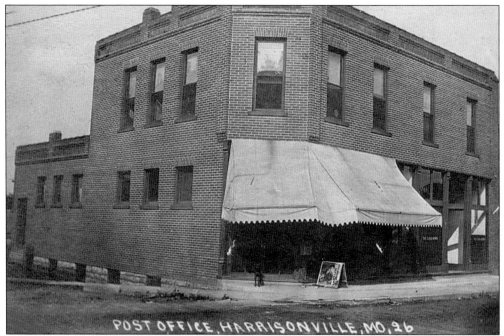

200 East Pearl Street, 1908. This Ritchie Brothers photograph shows the Victorian Del K. Hall Building, built between 1902 and 1908. It served as the post office from 1918 to 1925. In the later 1920s and 1930s, it housed Helen Kemper's Grocery and Yord's and Packer's Meats. In the 1960s, it housed Walker Home Supply, and from 1977 to 2001, Van's Artistic Flowers was located there. (Courtesy of David Atkinson.)

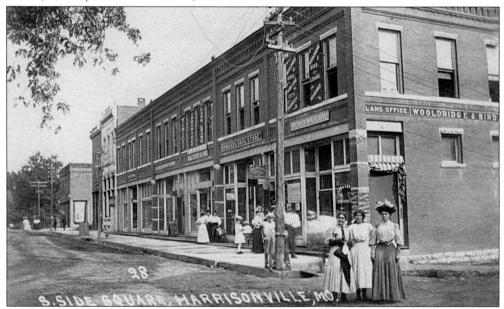

Square South Side, 1908. This Ritchie Brothers postcard shows the entire south side with shoppers. The businesses are, from left to right, Parson's Abstract, a millinery, Harrisonville Bank, Levi Smith's Meat Market, Howard's Drug Store, and Dunn and Bailey Grocery. The second floors housed offices such as Wooldridge and Bird Real Estate.

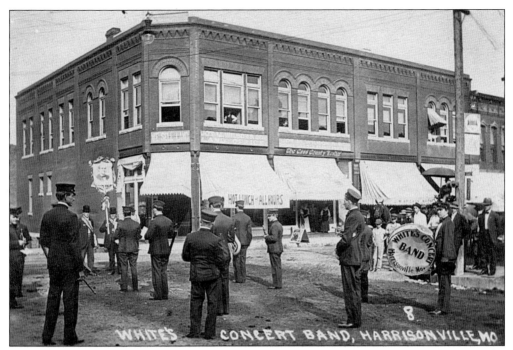

WHITE'S CONCERT BAND, 1908. The band is gathered on the northwest corner of the square for a political rally, as evidenced by the banner supporting presidential candidate William Jennings Bryan. He was the Democratic candidate, running against big banks and corporations as a champion of the common people. John White organized, taught, and led the town band for three decades. They played free concerts on the square into the 1930s.

NORTHWEST SQUARE, C. 1911. A military group and citizens gather on the northwest corner of the square. The businesses on North Independence Street are, from left to right Arthur Perkin's Restaurant, the *Cass County Leader*, an osteopath office, J.W. Bricken Harness, and McPheeters Restaurant. (Courtesy of Carol Bohl.)

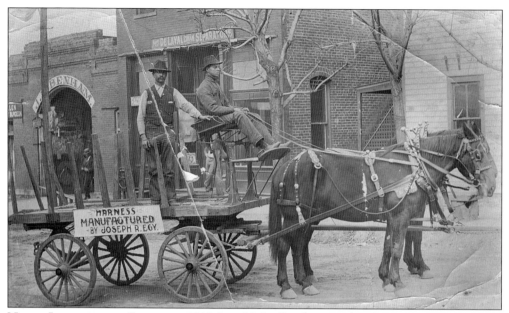

NORTH INDEPENDENCE STREET, C. 1910. Levi N. Ludlow began a drey business in Harrisonville in 1909, and the family continued with motorized vehicles and a taxi service until 1956. He is seen here with a son, either Clarence or Earl, in front of Denham's Livery on North Independence Street. Note the advertisement for Joseph Egy's harness. The family lived on North Independence Street near the Frisco depot. (Courtesy of Coleen Fowler Allen.)

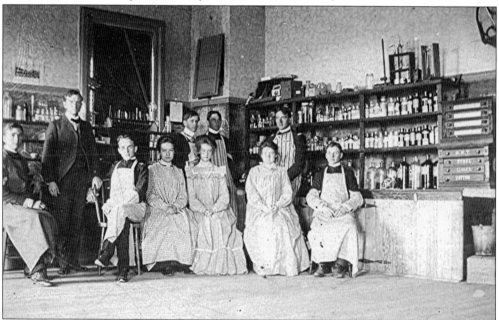

101 SOUTH LEXINGTON STREET, C. 1915. P.K. Glenn drugstore employees are ready for a day's work. The firm served the community for 78 years at this site, from 1909 to 1987. Founder Price Keller Glenn was followed by his son, George Allen Glenn, and George Allen's wife, Gladys. They sold paint and wallpaper on the second floor, which is what got them through the lean years of the Depression.

HARRISONVILLE SQUARE, C. 1912. Photographer, sign painter, and artist Tom Bird snapped a series of candid shots on the square and around town while he was in high school. This shot shows how the streets and sidewalks were cleaned before motorized street sweepers. Note the stairs going to the second story on the side of Kunze Jewelry in the background. (Courtesy of Allen Bird.)

WEST SIDE SQUARE, C. 1910. Below, rural mail carriers are lined up across South Independence Street on the west side of the square on a wet day. Note the pennants promoting the coming Chautauqua, a popular weeklong event that brought a variety of music, drama, lectures, and entertainment to small towns across the country.

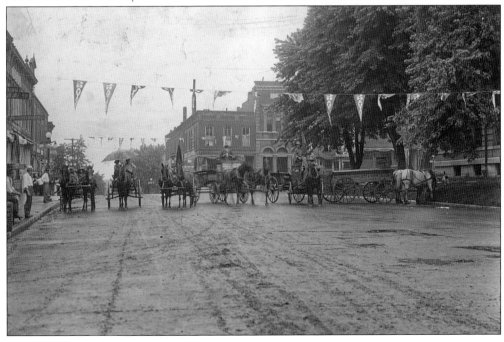

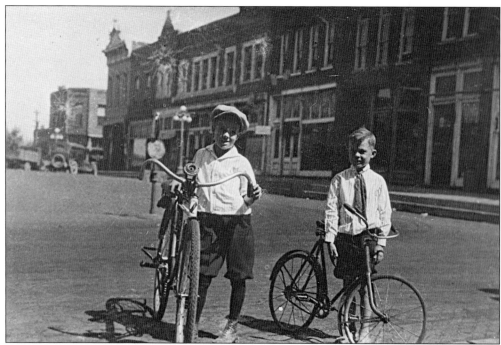

HARRISONVILLE SQUARE, C. 1915. These two unidentified boys biked to the square dressed in knickers, caps, and ties in this iconic image of a bygone era—one is even shoeless. The Tom Bird photograph has the south side of the square in the background. (Courtesy of Allen Bird.)

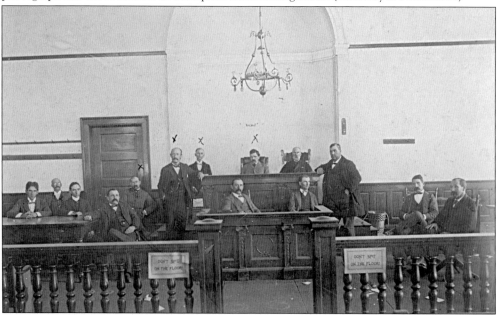

CASS COUNTY COURTHOUSE, C. 1900. This courtroom served the county for more than 100 years. The lawyers with Xs over their heads are, from left to right, W.D. Summers, D.C. Barnett, Charles Sloan, and William Jarrott. Note the sign on the bar in the lower right urging visitors, "Don't Spit on the Floor," next to a brass spittoon. The courtroom was restored to this original condition in 2008 with state and local funding.

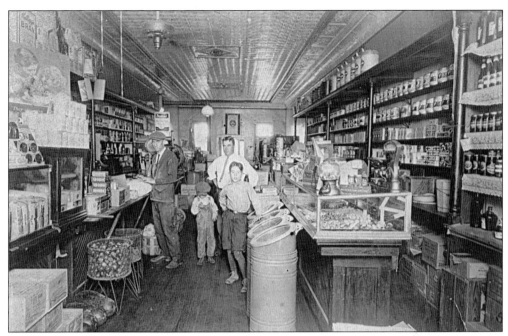

107 EAST WALL STREET, C. 1920. Walter and Winfrey Russell operated a grocery here from 1901 to 1927. The Russells also farmed about four miles southeast of Harrisonville. There were multiple family grocery stores on all sides of the square into the 1960s. (Courtesy of Doris Anstine Russell.)

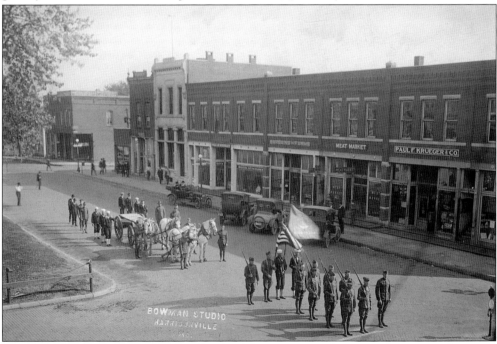

VETERANS PARADE, C. 1920. The south side of the square was the setting for an event honoring veterans in the early 1920s. This was before the retaining wall was built around the courthouse. There are still hitching rails on the east and west sides of the courthouse, but there is a traffic sign at the intersection of Wall and Independence Streets.

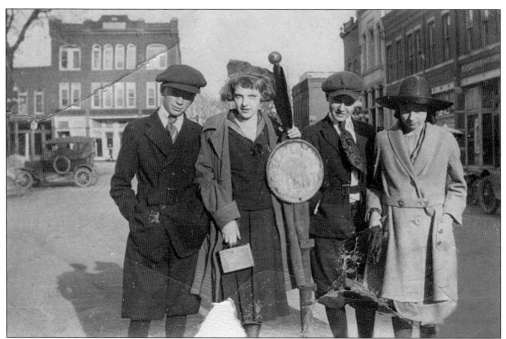

HARRISONVILLE SQUARE SOUTHWEST CORNER, C. 1920. The girl holding the standard is Will Ella Deacon, whose family were prominent Harrisonville merchants from the 1860s to the 1960s. Deacon taught math in the Independence, Missouri, schools and had Margaret Truman as a student. She also played cards with Bess Truman and friends at the Truman home. Deacon later operated the family hardware store on the east side of the square.

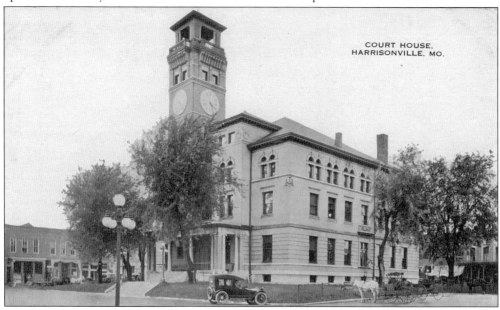

COURTHOUSE, 1920s. Following the paving of the square in 1915, horses could be hitched on the east and west sides of the courthouse, and cars could be parked on the north and south. Funding to provide a working clock in the tower, which was installed in 1909, was raised by the Women's Town Clock Club with bake sales and musical and variety shows.

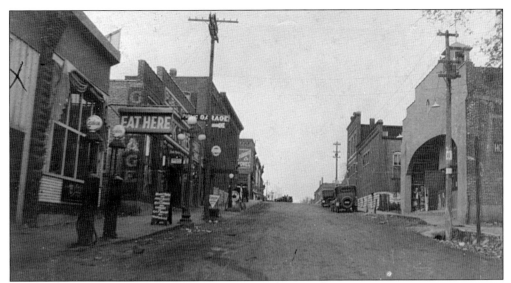

SOUTH INDEPENDENCE STREET, 1920. Looking north from Mechanic Street, the Schnell Theater is on the right and what appears to be a Jefferson Highway logo is on the utility pole. There is also a hotel sign indicating the site of the Southern Hotel. On the left, going up the hill, is LeRoy Fox's Buick garage, Frank Gross's restaurant with the "Eat Here" sign, and Carpenter and Wirt's public garage. (Courtesy of Margaret Kelley Fox.)

107 EAST WALL STREET, 1926. Walter Howard Russell (second from left) stands in front of Russell's Grocery. Constructed in 1901 following the 1900 fire that destroyed the south side of the square, it housed Russell & Winger Grocery (1901–1927), Russell's Variety (1930s), Cox's Dime Store (1940s), Russell's 5 Cent to $1 (1950s–1965), Copat Department Store (1975–1977), Wall Street Deli (1980–1983), and Youngers (2001–2008).

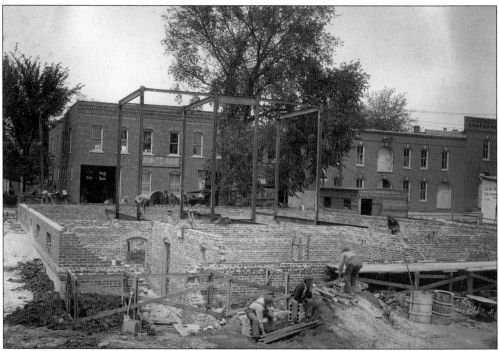

201 West Wall Street, 1925. Construction work on the new post office proceeds. This view looks north to the north side of West Wall Street and a John Deere dealership. Today, that building houses a flower shop with loft apartments above. The brick building to its right is Clemment's Hardware. The small white building on the extreme right housed a dairy and creamery.

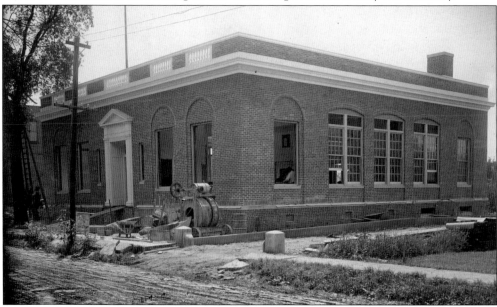

201 West Wall Street, 1925. This post office was built in 1925 for $41,700. The Colonial Revival brick building is the only one of its style in the Historic Square District. This was the first time the post office had not been on the square. In 1964, the post office moved to its present site on East Mechanic Street. This building now houses county offices.

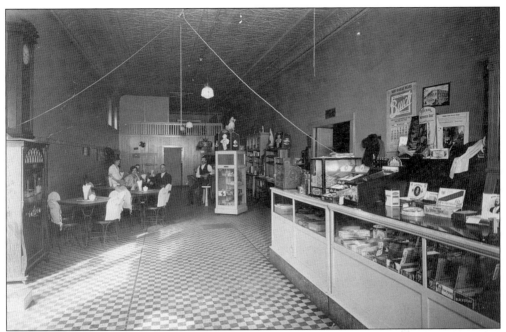

100 North Independence Street, 1927. A popular place to eat on the square in the 1920s and 1930s was the Griffin Grill. In earlier years, the building housed a restaurant run by Arthur T. Perkins, who sold it in January 1920 to the Corner Lunch Room. In later years, it housed a drugstore, a barber, a pool hall, the P.N. Hirsch department store (from 1961 to 1983), and offices.

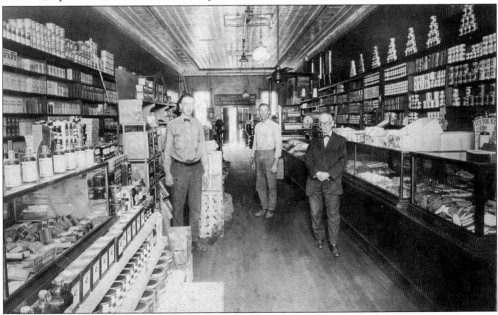

101 East Wall Street, 1927. Harvey Dunn (left) and Perry Bailey (right) operated a grocery store here from 1908 to 1927. In 1886, O. Smart was the grocer, followed by J. Burke (1900), Bailey & Schnell (1905), and Hugo Nyman (1950s). Then it housed Marquette Men's Wear, which closed in 1963, Les Young's Sears (1965–1976), Wards Downey Agency (1977–1979), Wards Hollands Agency (1980–1981), Teen Sports (1983), and Anderson & Milholland Law (1984–2003).

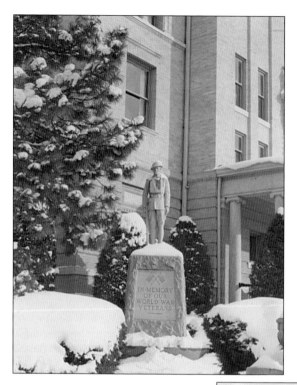

DOUGHBOY STATUE, 1975. A crowd of 10,000 filled the square at the 1929 dedication of the Doughboy statue honoring World War I soldiers. Ray Stewart, a young boy who lost his father in the war, laid the first wreath. The statue, made in New Hampshire of granite, was designed by E.J. Kling of Butler. It still stands at the southwest corner of the 1897 courthouse.

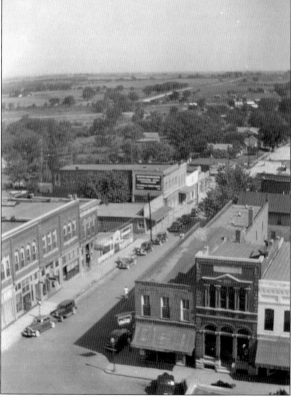

NORTHWEST HARRISONVILLE, 1930s. This view from the clock tower in the courthouse illustrates how little development there was in the northwest quadrant of Harrisonville in the 1930s. The Jefferson Highway (now Jefferson Parkway) travels north at the top of the photograph.

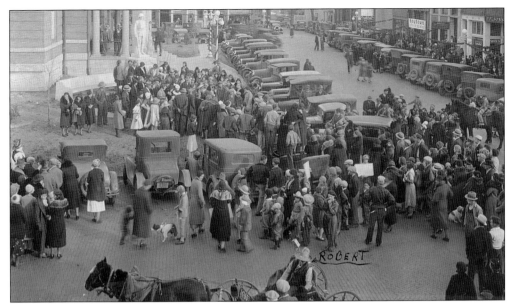

DECEMBER 23, 1933. The square is decked out for Christmas with garlands strung from lamp pole to lamp pole and a crowd is gathered to greet Santa Claus. Robert Helmick has driven his horse and buggy in from his farm several miles northeast of town. Several generations of children sat on Santa's knee at the square. (Courtesy of Jan Harper and Louise Cobb.)

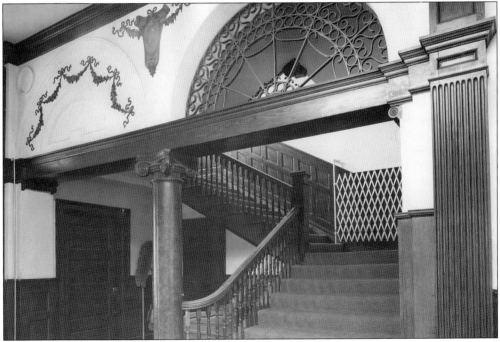

CASS COUNTY COURTHOUSE INTERIOR, 1980. The third county courthouse was completed in 1897. It was designed by the nationally recognized architectural firm of Walter C. Root in Italian Renaissance style. Note the hand-turned woodwork, wainscoting, and ornamental metal and plaster. The second-floor courtroom was extensively remodeled in 2008 and brought back to its original two-story design with a balcony and lunette windows.

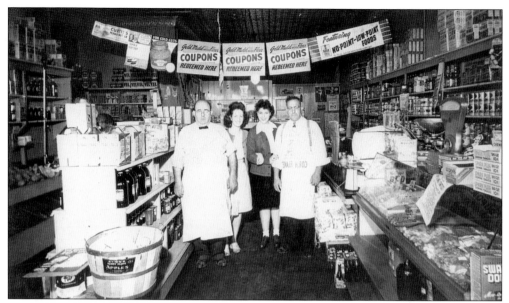

106 WEST WALL STREET, 1943. All five of the Scavuzzo sons served in World War II, so none are in this photograph. Note the signs indicating that the store accepted ration coupons. The family included, from left to right, Salvatore "Sam" Scavuzzo, Rosemary Scavuzzo (wife of Cosmo), Faustina Scavuzzo (Santo's daughter), and Santo (Charlie) Scavuzzo. The store was not yet self-service. (Courtesy of Salvatore Scavuzzo.)

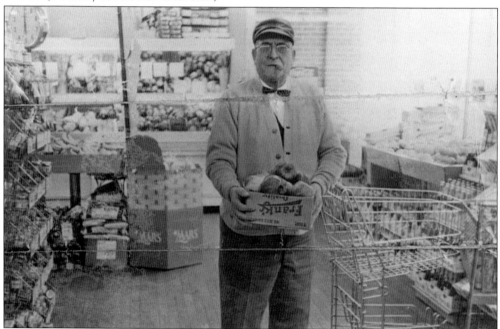

SANTO "CHARLIE" SCAVUZZO, C. 1950. Born in 1887 in Palermo, Sicily, Charlie and his brother Sam, born in 1879, came to Harrisonville in 1922 from Kansas City and opened a candy kitchen. They added a soda fountain, fresh fruits and vegetables, and a small stock of groceries. In 1935, they organized a grocery store, which was expanded and remodeled in 1946. They added the Highway 71 store in 1957. (Courtesy of Salvatore Scavuzzo.)

105 WEST WALL STREET, 1950s. Members of the Scavuzzo families worked in all aspects of Scavuzzo's Grocery. This photograph inside the uptown store shows Charlie at the far left in the cap and one of his five sons, Tony, in front at checkout. His other children were Cosmo, Salvatore, Luke, Joseph, Ida, and Faustina. (Courtesy of Salvatore Scavuzzo.)

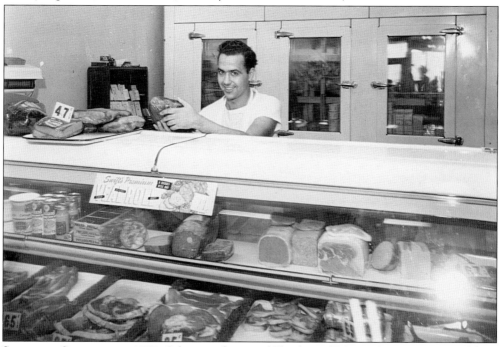

SALVATORE SCAVUZZO, C. 1950. Salvatore, the son of Charlie and Maggie Scavuzzo, returned from World War II and trained to become a meat cutter at the National School of Meat Cutting in Toledo, Ohio. He is shown here behind the meat counter at the uptown store. After it closed, he moved to the Highway Store on what is now South Commercial Street. (Courtesy of Salvatore Scavuzzo.)

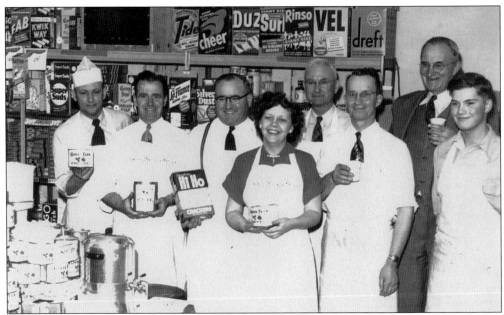

101 WEST WALL STREET, C. 1940. Russell's A&P Grocery served customers from 1937 to 1951. Note the choices of laundry detergents behind the employees. From left to right are Harry Holiday, unidentified, a representative of Clover Leaf Farms, Jim Staylor, Louise White, Clyde Russell Sr., a representative of Kitty Clover, and Clyde Russell Jr. (Courtesy of Willa Russell Dillon.)

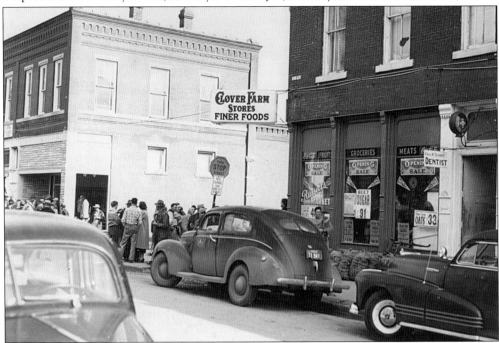

SOUTHWEST CORNER SQUARE, 1940S. Shoppers crowded the square on Saturdays for decades as farm families made their weekly trip to town. Parking spaces were at a premium, so folks would often park a car on Friday night to ensure a spot Saturday to sit and visit. Stores stayed open late into the night, sometimes until midnight.

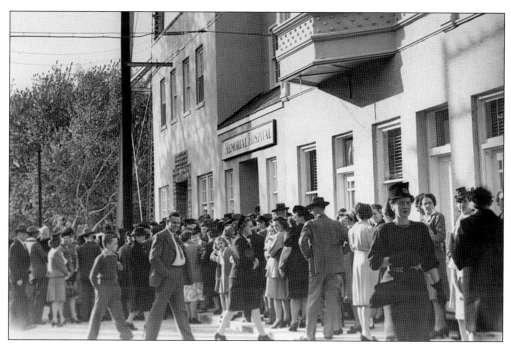

104 West Pearl Street, 1946. This photograph shows the grand opening of the newly established 30-bed Cass County Memorial Hospital. The two-story Queen Anne stucco and galvanized-iron building is the only example of this style in the historic square district. Through the years, it housed a bottling works, a saloon, a laundry, a grocery, and later a rest home, which closed in the 1990s. (Courtesy of Cass Regional Medical Center.)

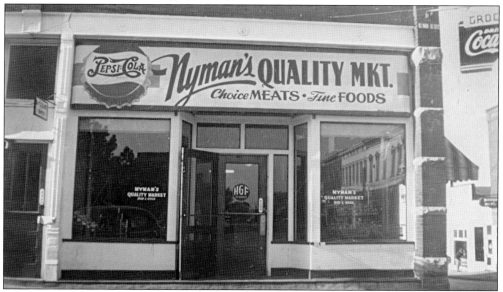

101 East Wall Street, 1948. Hugo and Alma Nyman purchased the Bailey Grocery Store on the southwest corner of the square in September 1946 and operated there until the store moved to new quarters in 1950, at the northeast corner of the intersection of South Street and South Commercial Street, the current site of GreenLamp Furniture. (Courtesy of Bruce and Gary Nyman.)

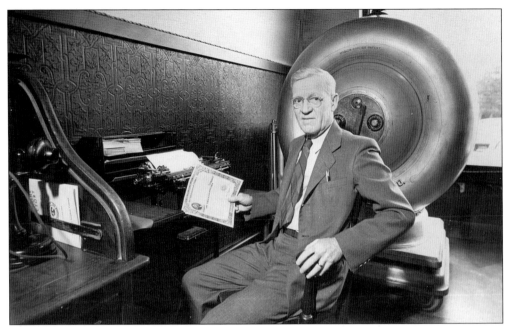

HERB VOLLE, ALLEN BANK, 1950. Herbert S. Volle lived his entire life in Harrisonville and served as president of the Allen Banking Company from 1944 to 1953. He is shown here at his desk near the safe and front window. That safe is still in the vault in the Country Club Bank on the square.

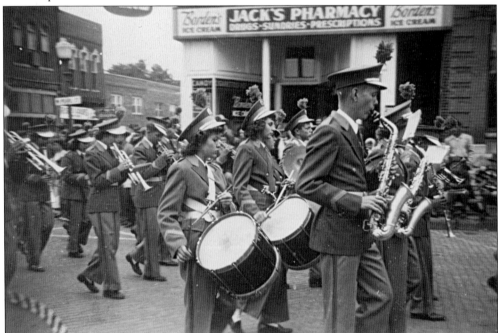

HARRISONVILLE HIGH SCHOOL BAND, 1949. The high school band marches east on Pearl Street on the northwest corner of the square in the Centennial parade. Jack Bedsaul's pharmacy is in the background. Bedsaul operated the business there from 1948 to 1958, when the building was torn down for the new Allen Bank building, which is now Country Club Bank.

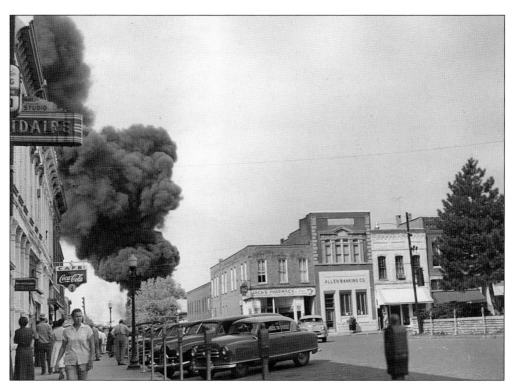

WEST SIDE SQUARE, 1953. Shoppers seem oblivious to the fire two blocks north of the square. The black smoke plume comes from burning tires at Anstine's Conoco station, which was completely destroyed. Note the parking meters.

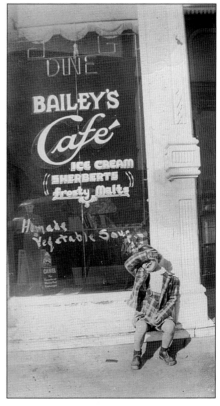

BAILEY CAFÉ, 1943. Alvin and Margaret Bailey operated a café on the west side of the square starting in 1941. Various family members worked there through the years. Their daughter Carol Sue is seen here. The Baileys also operated a dairy on their farm, which is now the Twin Pines Golf Course, and delivered milk in Harrisonville. (Courtesy of Carol Bailey Price.)

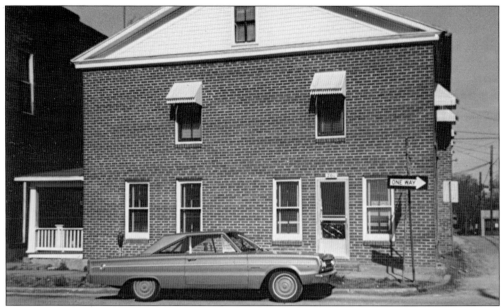

North Independence Street, c. 1955. The Pennington Hotel sat on the lot that is now parking north of Country Club Bank. The site originally had a cabin that served as a restaurant, which was enclosed and enlarged to create the Terrell Hotel in 1881. James Pennington purchased it and renamed it the Pennington Hotel. It was razed in 1958 to provide parking. (Courtesy of Doris Riggs.)

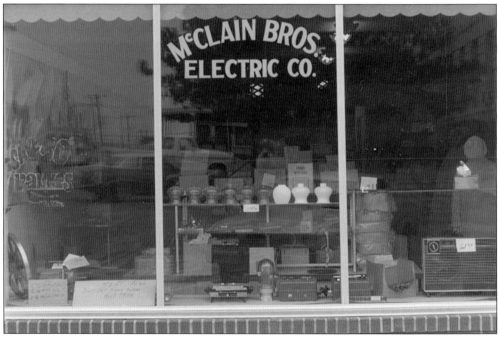

115 East Wall Street, c. 1960. This building, constructed in 1901, housed a variety of businesses, including a millinery (1901–1920s), Cox's 5 & 10 Cent Store (1930s), McClain Brothers Electric (1940s–1980), and clothing and thrift stores (1980–1995.) McClain Brothers worked out of the back of the building, while the front of the store offered a wide variety of home furnishings. (Courtesy of Julie McClain Cooper.)

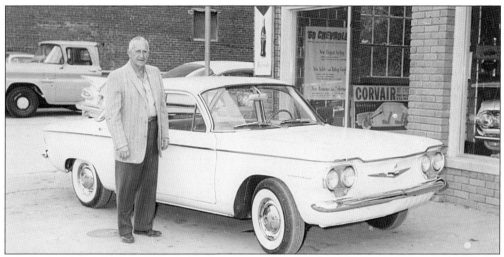

208 East Pearl Street, c. 1960. Herbert F. Acuff is seen here beside a Corvair in front of his Chevrolet dealership, which he and J.H. Harris purchased from Claude H. White in 1936. White had operated the business since the 1920s. Today, the building is the site of the Harrisonville Police Department.

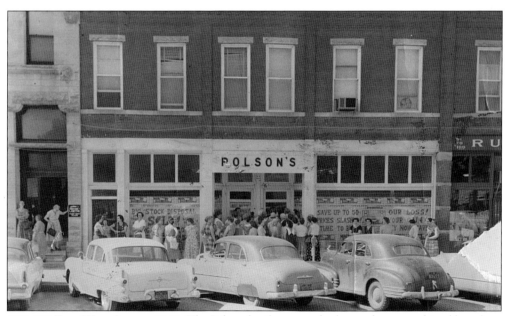

109–111 East Wall Street, 1962. The Polson family operated a dry goods store at this address from the 1940s until its closing in 1962. The signs in the windows indicate it is a closing sale, and a crowd is gathered and waiting for the doors to open. The space was next occupied by Copat Department Store (1964–1974), Phillip's on the Square, the Cass County Annex, and Youngers.

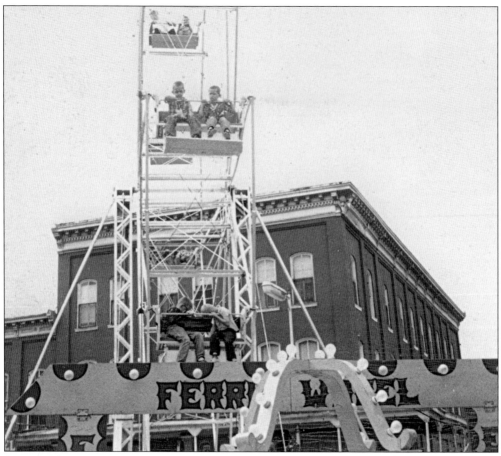

SQUARE MERCHANTS CARNIVAL, 1965. For years in the mid-1900s, the three car dealerships around the square—Ford, Chevrolet, and Buick—jointly sponsored a carnival to coincide with the release of new car styles. The ferris wheel was always set up in front of the Hotel Harrisonville on the northeast corner of the square. (Courtesy of Doris Riggs.)

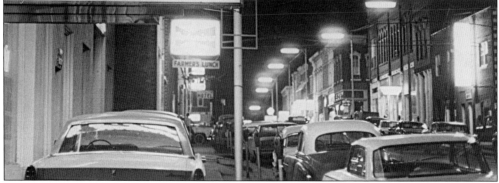

NORTH INDEPENDENCE STREET, C. 1965. This rare night shot looks south on North Independence Street in front of Burris Ford. Note the Farmers Lunch and Pennington Hotel signs on the east side of the street. Perhaps this was a Saturday, as all the parking spaces are full. For decades, the square filled with shoppers on Saturday, and stores stayed opened until the last customer went home, sometimes midnight or later.

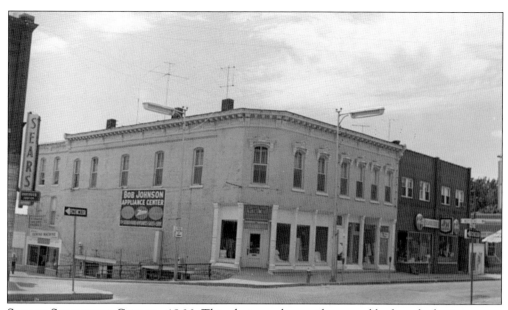

Square Southwest Corner, 1966. This photograph provides a good look at the businesses on the southwest corner of the square in the mid-1960s. From left to right are Youngs Sears Catalog (1965–1976), Bob Johnson Appliance (1966–1967), Singer Sewing Machine and Fabrics (down the hill), Mar-Kee women's clothing (1955–1986), and Scavuzzo's Grocery (1934–1981).

115–117 South Independence Street, 1969. The Deacon brothers established a hardware store in 1868 on the west side of the square. They built this building in 1892, with the upper floors housing county offices. The Masonic lodge met on the third floor for decades. Deacon Hardware closed in 1969 and was followed by a Gambles Store until the Crouch, Spangler, and Douglas law firm bought and remodeled it in the 1980s.

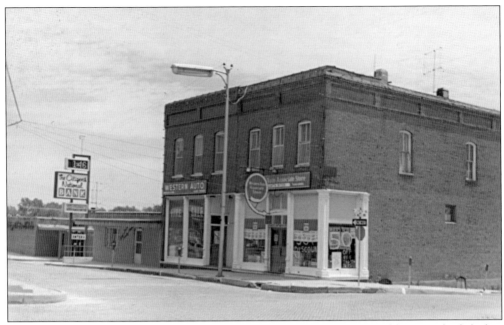

201, 203 EAST WALL STREET, 1971. This two-story brick vernacular building was built before 1885. It housed the post office from 1895 to 1902. The west side housed the Corner Variety Store in the 1920s and Western Auto from the 1950s to the 1980s. The east side housed the *Cass County Democrat* from 1901 until 1958, when J.W. Brown, who purchased the newspaper in 1955, moved it to South Lexington Street.

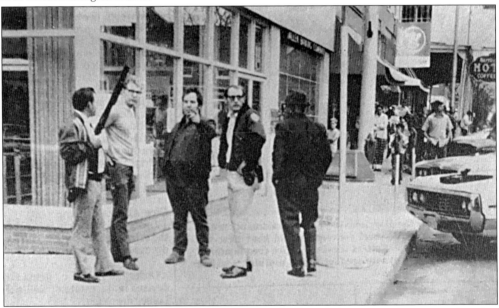

PEARL AND INDEPENDENCE STREETS, APRIL 1972. The tragedy known as the square shooting unfolded on April 21, 1972, when Charles Simpson, a self-styled counterculture "hippie," went on a rampage, killing two policemen and a bystander, wounding two Allen Bank employees and county sheriff Bill Gough, and then killing himself with his M-1 carbine. Harrisonville and the nation grappled with the emotions and unrest of the clash between generations and cultures.

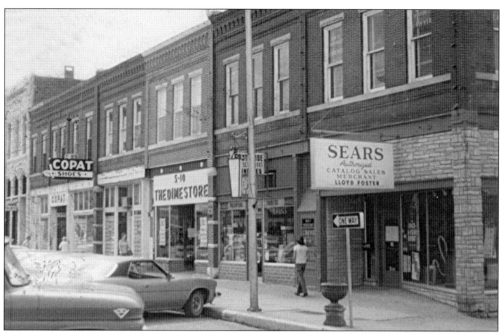

Square South Side, 1972. These businesses are, from left to right, Williams' Jewelry, Copat Department Store, The Dime Store, Foster's Southside Drugs, and Sears Catalog Store. Circumstances in the 1970s, such as the square shooting and Wal-Mart coming to town, led to the gradual decline of shopping and family businesses around the square.

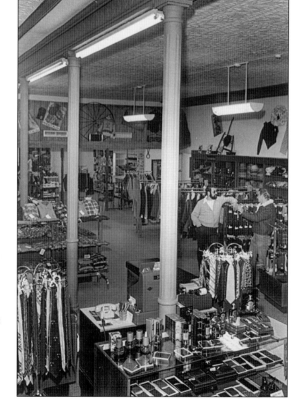

109–111 East Wall Street, 1975. Owner Phil Zaroor is seen here inside Phillip's on the Square. Zaroor opened the store in 1974 on the west side of the square in the former Conley's store and moved it in 1975 to this larger location, the former Copat Department Store. Zaroor featured men's and women's clothing. The store closed in 1981.

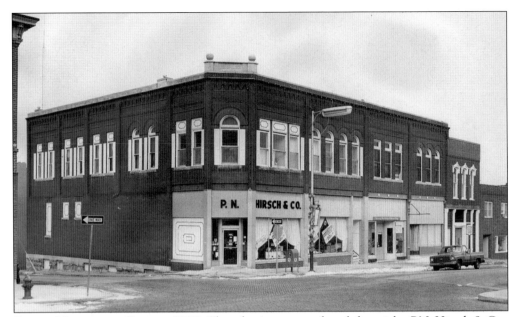

SQUARE NORTHWEST CORNER, 1980. These businesses are, from left to right, P.N. Hirsch & Co., Dorothy Worthley's Fashion Shop, unidentified, and Connie White's School of Dance. Only White's Dance remains today.

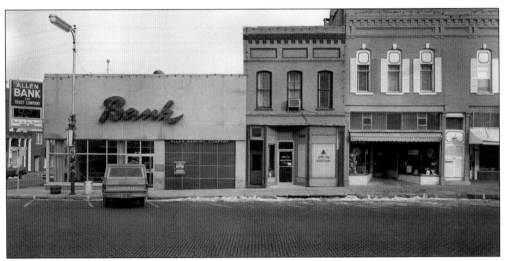

SQUARE NORTH SIDE, 1980. These businesses are, from left to right, Allen Bank, Legal Aid, Nancy's Hallmark Haven, and Brandt's Appliance. Today, the same structures house Country Club Bank, Scott Friedrich Law, unoccupied, and Edward D. Jones.

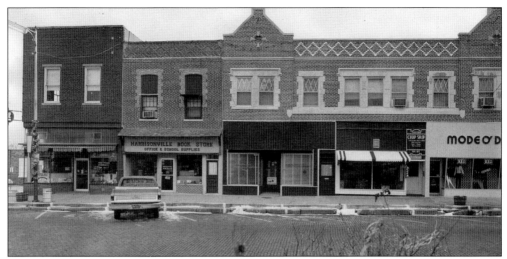

SQUARE EAST SIDE, 1980. These businesses are, from left to right, P.K. Glenn Rexall Drugstore, Harrisonville Book Store, Cass County Land Title, East Side Barber Shop, Eddie Horn's Chap Shop, and Mode O'Day Fashionaire.

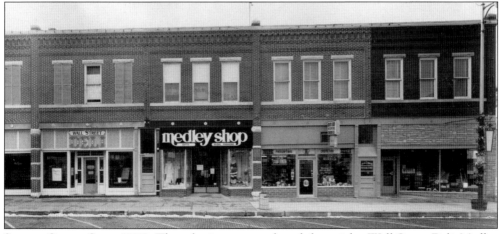

SQUARE SOUTH SIDE, 1980. These businesses are, from left to right, Wall Street Deli, Medley Shop, Graham's Southside Drugs, and Wards Holland Agency.

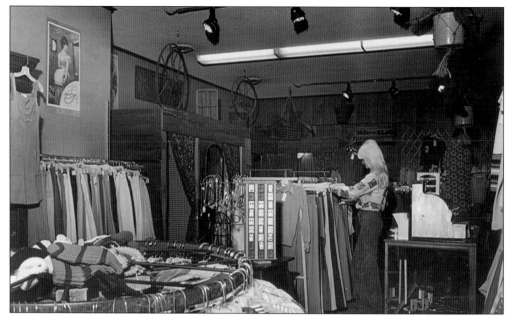

108 South Independence Street, c. 1980. The Alley Shop, which featured women's and junior fashions, operated at this address from 1975 to 1985. It was owned by Bill and Marge Carpenter of Louisburg, Kansas, who also owned stores in Louisburg, Paola, and Ottawa. Joyce and Marci Moore, Karen Snead, and many others worked there for several years.

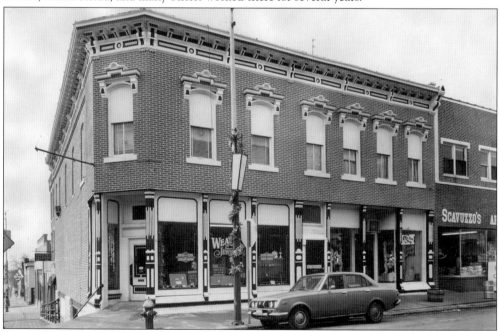

Southwest Corner Square, 1980. This photograph shows Weaver's Jewelry (1975–1982) at 101 West Wall Street. The structure was built in the late 1880s as the First National Bank, which failed in 1893. It housed Will T. Price Jewelry from 1913 to 1922, Russell's A&P Grocery from 1937 to 1951, Bob Johnson Appliance from 1966 to 1967, a fabric store, and Printed Products (1984). The next door west is the Mar-kee Shop, followed by Scavuzzo's Grocery.

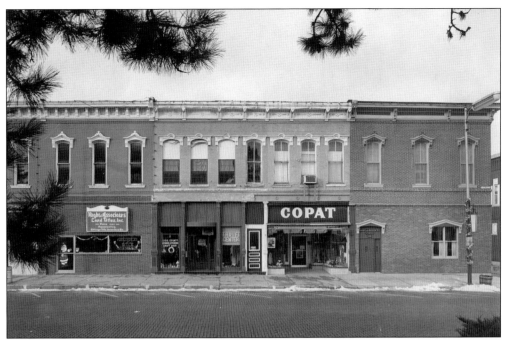

WEST SIDE SQUARE, 1980. All of these buildings were constructed in the mid-1880s. The second-story facades have changed little from this brick Italianate style. These businesses are, from left to right, Hight & Associates Land Title (which has bricked in the front), a thrift store, Copat Department Store, and the Hight and Ballew law office, with bricked-in front.

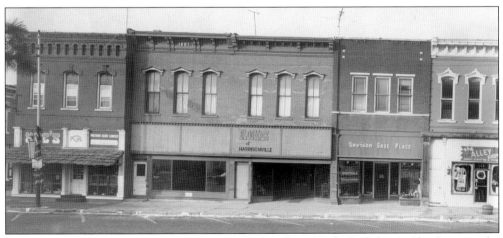

WEST SIDE SQUARE, 1980. Although many of the first-floor facades had changed by this time, the second floors remain authentic to the late-1880s Victorian and Italianate styles. These businesses are, from left to right, Noe's Jewelry, Bloomies Home Furnishings, Davison Shoe Place, and The Alley women's apparel.

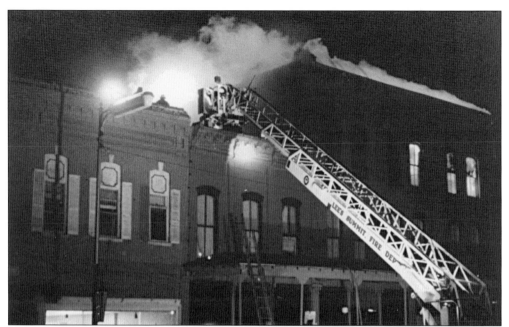

HOTEL HARRISONVILLE, EAST PEARL STREET, 1983. A fire that began in the kitchen of Bowiler's Restaurant engulfed this 100-year-old structure, which housed several businesses at the time. Lee's Summit sent a ladder truck to reach the third story. The building was razed after it was declared structurally unsafe, and the site is still vacant. (Courtesy of Nancy Bruens.)

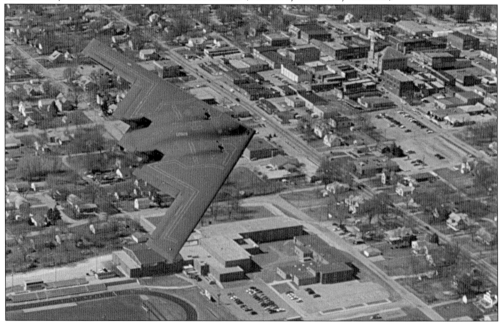

BOMBER OVER HARRISONVILLE, 1994. The B2 Bomber, also known as the Stealth Bomber, was new in 1994 and was often seen in area skies as it flew from its home at Whiteman Air Force Base in Knob Knoster, about eighty miles east of Harrisonville. This photograph was given by Brig. Gen. Ronald Marcotte to congressman Ike Skelton, who gave it to the mayor at the time, Bill Mills. (Courtesy of Bill Mills.)

Three
Businesses Come and Go

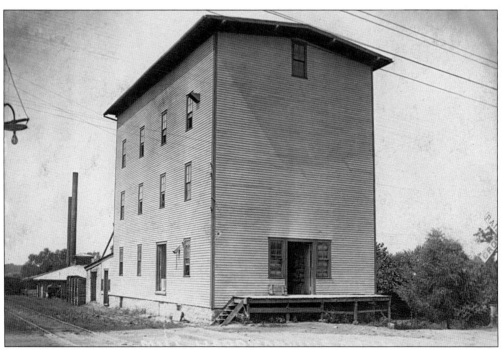

North Independence Street, c. 1900. This mill was built in 1892 on land next to the Frisco rail line. It had a capacity of at least 20,000 bushels of grain a day. Note the city power plant behind the mill. In later years, the mill was the Farmers Elevator. Ownership changed many times before it was razed in 1988. Today, Cass County Monument Company sits on this site. (Courtesy of David Atkinson.)

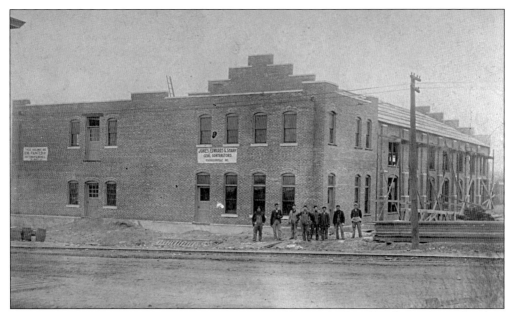

JONES, EDWARDS AND SHARP BUILDING, 1888. Scaffolding and piles of lumber indicate this shop is under construction either for or by Jones, Edwards and Sharp General Contracting. A.J. Sharp and his brother I.M. operated Harrisonville Machine Works and Foundry, established in 1883. Fire totally destroyed the plant in 1903, but it was rebuilt soon after.

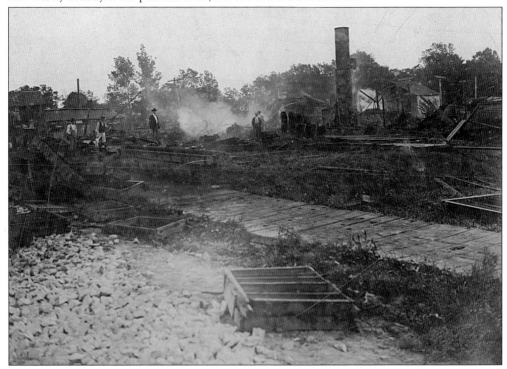

SHARP FOUNDRY AND MACHINE WORKS, 1903. Fire completely destroyed the buildings of the Harrisonville Foundry and Machine Works on September 22, 1903. A.J. Sharp had retired in April 1903, but I.M. rebuilt the plant after the fire.

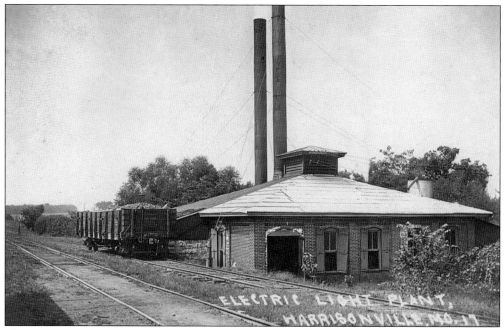

HARRISONVILLE ELECTRIC PLANT, 1908. This is the first city electric plant, built in 1895 under the supervision of Harrisonville mayor George Bird. The first lights came online in April and included arc lights for streets to run until midnight and incandescents for homes to run all night. It was so bright that rural residents were alarmed, thinking there was a big fire in town. (Courtesy of David Atkinson.)

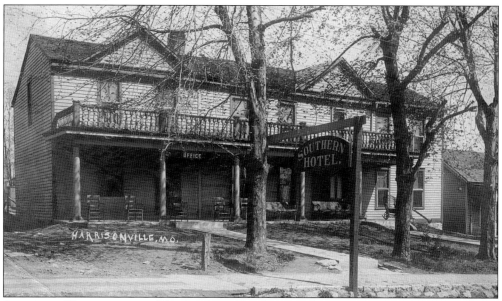

SOUTHERN HOTEL, C. 1910. The Southern Hotel sat on the east side of South Independence Street, one block south of the square. Tradition says it was remodeled from Charles Keller's log house most likely in the late 1840s or early 1850s. An 1883 addition gave it a total of 17 rooms. It had several owners and was named Angle House, Higgins House, and Lamar House before ceasing operation in 1936.

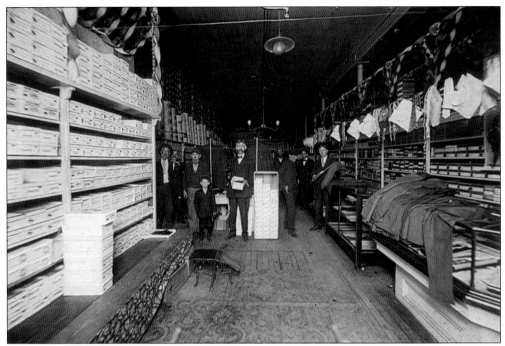

110 SOUTH INDEPENDENCE STREET, 1907. Thomas W. Clemments and Granville Maupin formed the Globe Trading Company in 1906 in the two-story brick Taylor Building at the intersection of Mechanic and South Independence Streets. The next year, they moved to this building on the west side of the square. A 1912 newspaper article declared this store "the largest trade in dry goods of any store in Cass County."

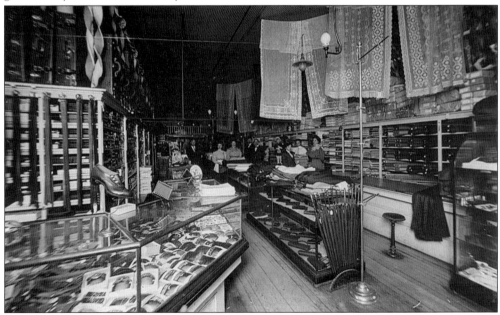

110 SOUTH INDEPENDENCE STREET, 1907. This is the interior of the Globe Trading Company dry goods store, which was called "The Big Little Store." Note that they offered both gas and electric lights. This building housed the A-C Mercantile from 1916 until it closed in 1969.

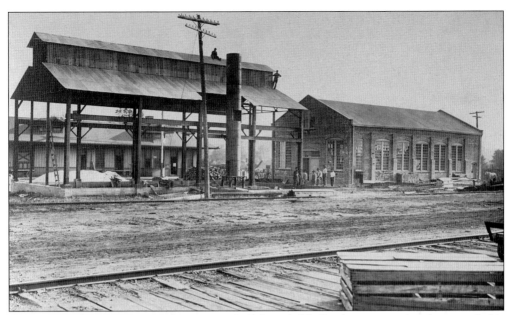

GWATHMEY MANUFACTURING COMPANY, 1918. Joseph H. Grathmey owned and operated this foundry just north of the Missouri Pacific tracks from 1917 until 1943. It included three cupolas, molding machines, a large core oven, and a complete pattern shop. They made gray iron castings, industrial and domestic gas burners, and Red Mule garden tractors. Today, the building is owned by Shelton and Sons Construction Company. (Courtesy of Rebecca Young-Marquardt.)

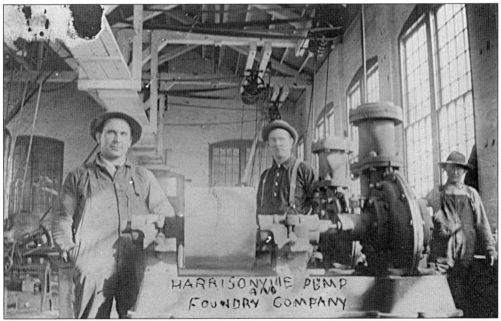

GWATHMEY MANUFACTURING INTERIOR, 1918. This foundry provided some 40 jobs for 25 years, closing in 1943. Workers made stove parts, heavy river-crossing pipeline clamps, boiler sections, commercial boilers, locomotive smokestacks, gas furnaces, and incinerators from new iron mixed with scrap iron. During the Great Depression, the operation cut back to three days a week. All cast-iron parts were made by hand. (Courtesy of Rebecca Young-Marquardt.)

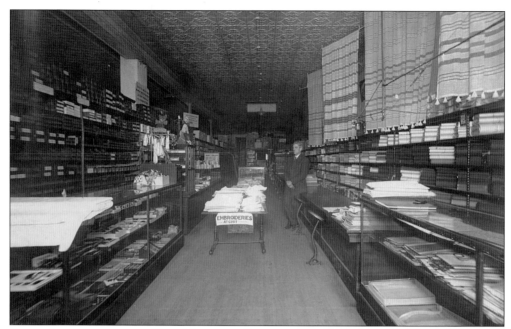

SOUTH INDEPENDENCE AND EAST MECHANIC STREETS, 1918. Lee F. Hartzler is seen here in his mercantile store at the northeast corner of South Independence and East Mechanic Streets in what was known as the Taylor Building. This is half of the store; the other half was a grocery store known as Hartzler and Zeigler, which later became George Carter's grocery in the 1930s.

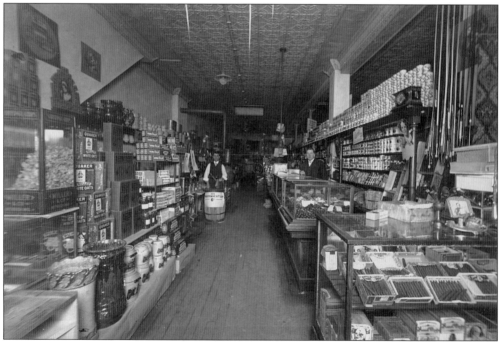

SOUTH INDEPENDENCE AND EAST MECHANIC STREETS, 1918. Levi Zeigler (left) and Noah D. Hartzler are seen here in their grocery store on the northeast corner of South Independence and East Mechanic Streets. Note the multitude of cigars in the case at the front right, the stacks of Quaker Oats boxes on the left, and the sign on the barrel for "New Buckwheat Flour 6¢."

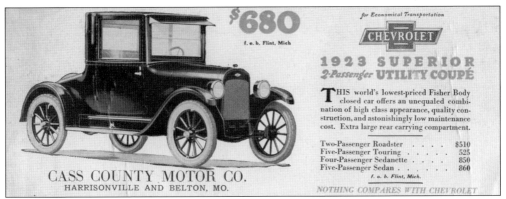

1923 ADVERTISING CARD. One of the early automobile dealerships in Cass County offered the Chevrolet coupe for $680. As mass production geared up, the middle class could afford to purchase cars, which drove the need for hard-surface roads and the switch from train transportation of goods to highway transportation. Car-related businesses such as gas stations, garages, and dealerships sprang up in Harrisonville, providing many jobs.

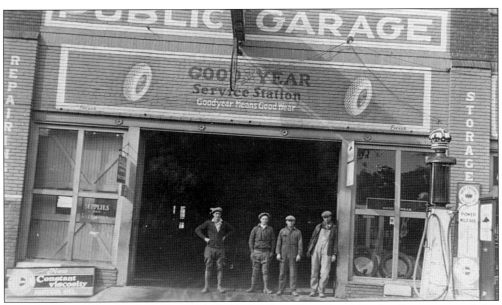

210 SOUTH INDEPENDENCE STREETS, C. 1930. Brothers Daniel and Harlan Davis operated this garage from the early 1920s until 1967. Harlan came to town in 1921, and Dan followed in 1925. The garage provided auto parking and storage on the second floor by taking cars up on an elevator. The signs indicate they sold Goodyear tires, Champion spark plugs, Mobiloil, and Red Crown gasoline. (Courtesy of Mary Doris Davis.)

MUNICIPAL LIGHT AND WATER PLANT, C. 1930. This structure still stands between North Lexington and North Independence Streets at Forest Street. It served as Harrisonville's light and water plant for decades, from the early 1900s until both were moved in the latter part of the century. At the time it was built, it sat near the Frisco train tracks.

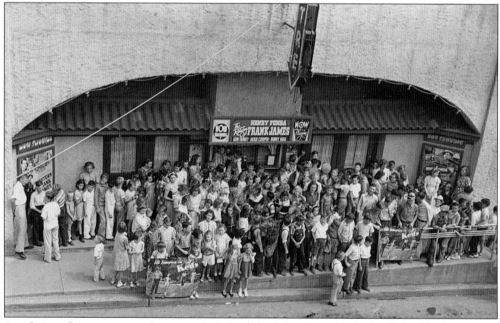

211 SOUTH INDEPENDENCE STREET, 1941. Built by John R. Schnell, the Schnell Theater was sold to Arthur T. Perkins in 1922. It was last known as Lee Theater after Lee Jones bought the business and building. His manager, Bill Thomas, extensively renovated the facility. This picture was taken in September 1941 when the Keds Shoe Company had a special show with Henry Fonda in *The Return of Frank James*.

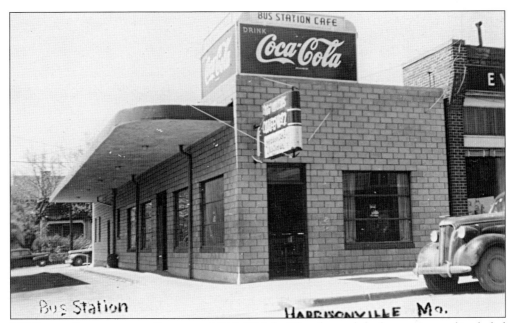

310 South Independence Street, c. 1940. This building housed the bus station and included a café for decades, serving Crown Coach and Jefferson Bus Lines, among others. In the early 1980s, it was the home of Guido's Pizza, and today it houses Styron Engineering. (Courtesy of David Atkinson.)

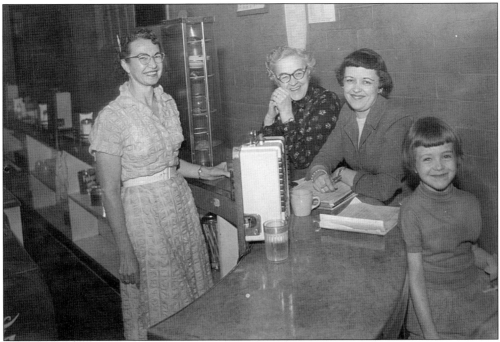

310 South Independence Street, 1956. This building, due north of the Marler, Wirt, Allen Park, now houses Styron Engineering. It served as the bus station and café for decades. Seen here in May 1956 are, from left to right, Eleanor Dudley, Florence "Toppy" Robertson, Betty Hambright, and Debbie Hambright. Guido's Pizza was there for a time in the early 1980s.

202 West Wall Street, 1937. Edward Kennedy built this structure in 1929 to house his New Method Laundry. He opened his first laundry in Harrisonville in 1897 with the first steam equipment in the county. After his death, his wife and sons operated the business until World War II. The building later housed a sewing factory, a library, and an electrical products business before being demolished. (Courtesy of Carol Bailey Price.)

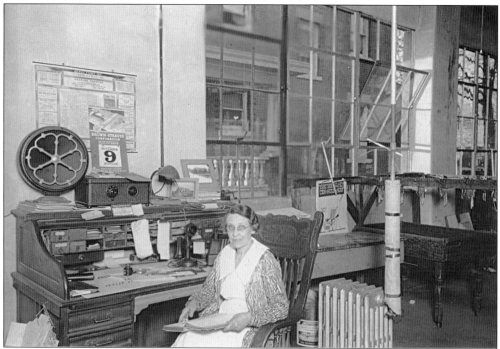

202 West Wall Street, 1930s. Ethel Kennedy sits at her desk inside the New Method Laundry, which she ran from 1929 to 1943 following the untimely death of her husband, Ed Kennedy, in 1929. (Courtesy of David Atkinson.)

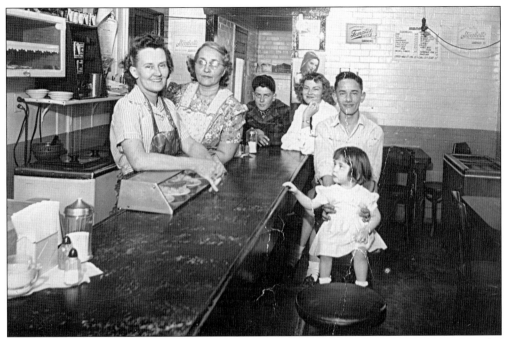

CITY SERVICE STATION CAFÉ, 1947. The café was located on what was then Highway 71 and is now the 1300 block of South Commercial Street. From left to right are Anna Russell, Fern Burton, Jack Russell, Betty (Russell) Wilmoth, George R. "Bob" Russell, and Jane (Russell) Proctor. Note the prices on the signs: coffee and milk were 5¢, a ham sandwich was 30¢, chili was 20¢, and soup was 15¢. (Courtesy of Doris Anstine Russell.)

RUSSELL'S CITY SERVICE STATION, 1947. This gas station sat on the southwest corner of the intersection of South Street and Highway 71, now South Commercial Street. Tat Russell ran the station from 1945 to 1948. Other family members also worked in the café. (Courtesy of Doris Anstine Russell.)

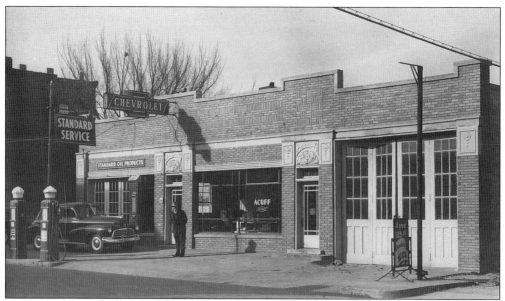

208 EAST PEARL STREET, 1947. This buff-brick building with Arts and Crafts and Art Deco elements was built in the 1920s for the White Motor Company. Herb Acuff owned it from 1939 until 1964, when it became Moore-McLain Chevy/Olds. It housed Need's Body Shop in the early 1970s. It was converted into the Harrisonville Police Station in 1977 and was remodeled in 1983. (Courtesy of Janet Allbaugh.)

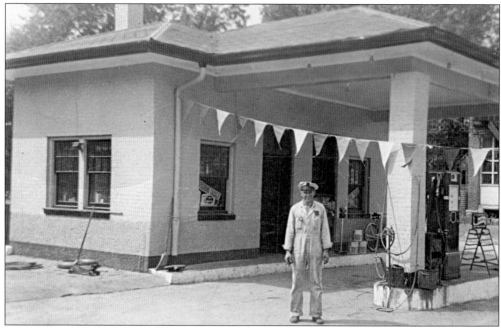

HOKE FILLING STATION, C. 1950. George Hoke moved to Harrisonville in 1945 and ran this filling station on East Pearl Street for seven years. Presently, this is the site of the telephone company building across from city hall. He ran a station at Mechanic and Lexington Streets for about nine years, a Skelly station and tow business at Mechanic and Independence Streets for 22 years. (Courtesy of Clara Hoke.)

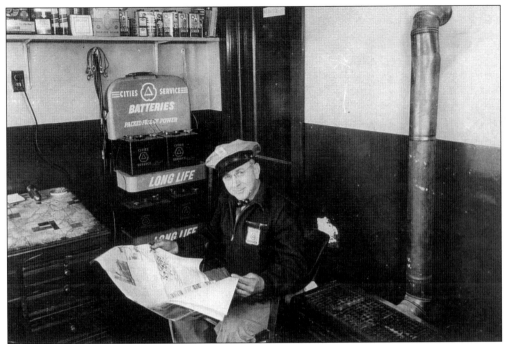

207 East Mechanic Street, 1951. Wallace Mitchell checks the news at the office of the Cities Service station, just west of the present post office, in 1951. He leased stations at two other sites: the Davis Brothers station on South Commercial Streets in 1946, and a Phillips station on North Commercial Street, where O'Reillys Auto Parts sits today. George Hoke purchased the Cities Service station in 1954. (Courtesy of Doris Mitchell Hines.)

1205 South Commercial Street, 1952. Hugo Nyman moved his grocery store from the south side of the square to this building in 1950. He sold Nyman's Food Mart in 1967, but it remained a grocery until the 1980s, when the Lampes and Greenwells started their furniture store, GreenLamp. Today, it is the site of Bruen's GreenLamp Furniture. (Courtesy of Bruce and Gary Nyman.)

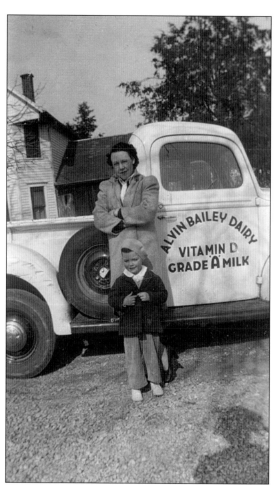

BAILEY DAIRY, 1943. Alvin and Margaret Bailey operated a dairy on their farm, which is now the Twin Pines Golf Course, and delivered milk in Harrisonville. Shown here are Margaret and daughter Carol Sue. (Courtesy of Carol Bailey Price.)

1505 SOUTH COMMERCIAL STREET, c. 1965. Harold Cherry built the structure below in 1946 or 1947 and sold DeSoto cars. J.B. Coke was an employee. Alvin, Margaret, and Lester Bailey established Bailey's Speed Wash here in 1963. Alvin operated it until his death in 1995. The business still operates at this site under new ownership. (Courtesy of Carol Bailey Price.)

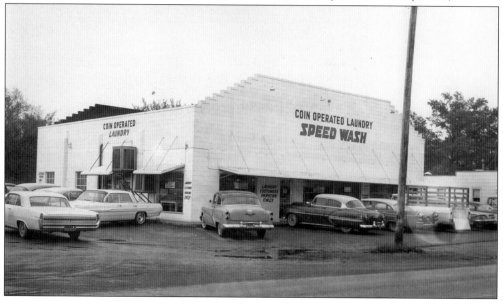

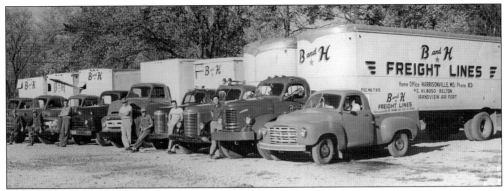

B AND H FREIGHT LINES, 1953. Trucks and drivers of B and H are seen here on the city lot on East Wall Street. Owner Kenneth Swigart lived in a house at the current location of Cass County Publishing. Swigert is in the center with his arms folded and a hat. To his right is Andy McGraw Crook. The trucks include a 1952 Studebaker, Internationals, a Diamond Rio, and three Fords. (Courtesy of Karen Carrel.)

B AND H FREIGHT LINES, 1953. Kenneth Swigart started this firm in 1947 in Belton but moved to Harrisonville in 1950. The name stands for Belton and Harrisonville. His wife, Doris, was the company bookkeeper. His son Theron and daughter Karen bought the firm in 1973. Theron's son Darren established the flatbed division in 1980, which still operates as Show Me Trucking. Paul Billings bought B and H in 1997. (Courtesy of Karen Carrel.)

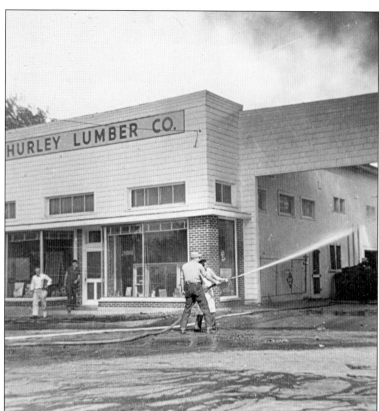

305 NORTH INDEPENDENCE STREET, 1953. Hurley Lumber Company was saved from the fire that destroyed Anstine's Conoco to the south. Manager Elmer Adkins is seen here taking valuable documents out of the store. The shorter, dark-haired man helping on the hose is volunteer fireman Luke Scavuzzo, who is still wearing his grocer's apron. (Courtesy of Doris Anstine Russell.)

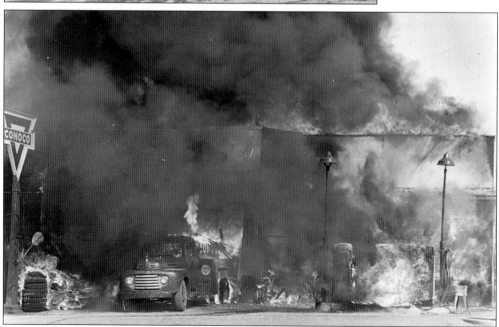

NORTH INDEPENDENCE AND CHESTNUT STREETS, 1953. Fire destroyed "Shorty" Anstine's Conoco filling station in September 1953. Nothing was ever built back on the lot and it is now the parking lot south of Hon Heating and Cooling. (Courtesy of Jan Harper and Louise Cobb.)

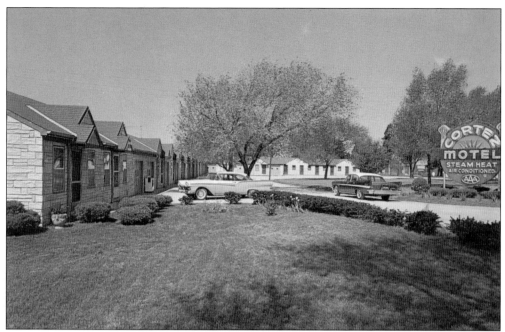

1302 NORTH COMMERCIAL STREET, 1960. The Cortez Motel was built by Harold Bailey in 1947 and still operates at this site. In the 1950s, it was run by Jess and Anna Bailey, and from 1958 to 1964 it was run by Alvin and Margaret Bailey, who sold it to Ralph and Opal Hawkins. It sat on Highway 71 before the present dual-lane highway was built in the late 1960s. (Courtesy of Carol Bailey Price.)

NORTH COMMERCIAL STREET, C. 1963. In the background, just north of the Cortez Motel, is the Red Onion Restaurant, built in 1934. For years, it was a haven for hungry Highway 71 motorists, serving 10¢ hamburgers and free coffee. It was razed in 1981 when the intersection of Locust and Commercial Streets was realigned. It is now the site of the pocket Vietnam/POW Memorial Park. (Courtesy of Carol Bailey Price.)

SHAMROCK MOTEL, C. 1950. This motel stood at the intersection of Highways 71, 35, and 7, which is now the intersection of South Independence and South Commercial Streets. The structure has housed Moeller's Veterinarian Clinic, a hair salon, a dog-grooming business, and various other businesses through the years.

SOUTH LEXINGTON AND EAST MECHANIC STREETS, C. 1970. Looking east, one can see Harrisonville Glass on the north side of the street. The site of the filling station later housed Plaza Savings; Troutt, Beeman and Company; and Coffelt Land Title.

NORTH COMMERCIAL STREET AND 71 BYPASS. The J&J Phillips 66 Station stood near the current McDonalds. Co-owners Jim Sutton and John Collings accepted a "Mystery Award" for providing full service to a secret shopper. The station was razed to make room for the new 71 Highway interchange, and the business relocated to its current location on Rock Haven Road.

JOHNNIE'S PHILLIPS 66, 1966. The new station on Rock Haven Road is seen here during its grand opening. John Collings operated the station from 1966 to 2009. The structure still stands but is no longer an operating station.

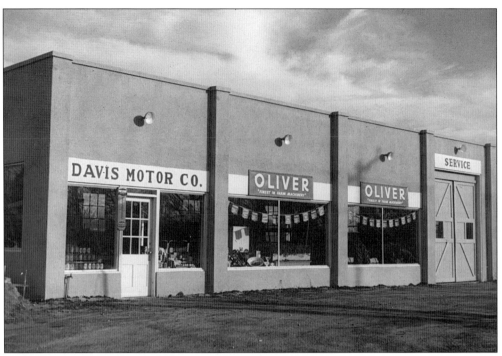

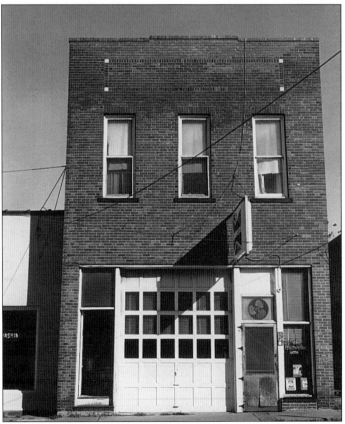

DAVIS MOTOR COMPANY, SOUTH COMMERCIAL STREET. Upon his return from World War II, Dan Davis closed the Davis Brothers Tourist and Amusement Park and opened the dealership above across the highway on the east side of South Commercial Street, where the fire station and EMT building stands today. He sold Olivers and Buicks for a few years, but soon sold out and moved to the uptown site. (Courtesy of Mary Doris Davis.)

NORTH INDEPENDENCE STREET, C. 1965. Jim Sloan operated the Farmers Lunch Restaurant at this site between Burris Ford and the Pennington Hotel from 1952 to 1962. The building was razed to make way for a parking lot.

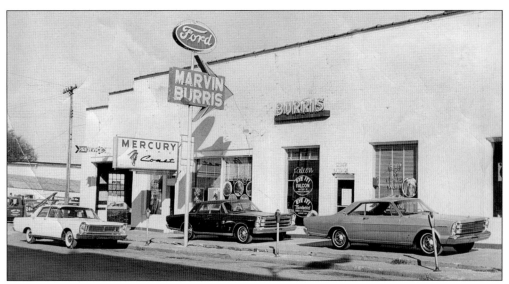

209 NORTH INDEPENDENCE STREET, C. 1965. Marvin Burris established his Ford dealership in 1952 with partner Bart Henderson. Cars were always parked in front on the sidewalk as shown. Burris sold the business to G.R. Milner in 1977. The site is now the parking lot north of Country Club Bank. (Courtesy of David Atkinson.)

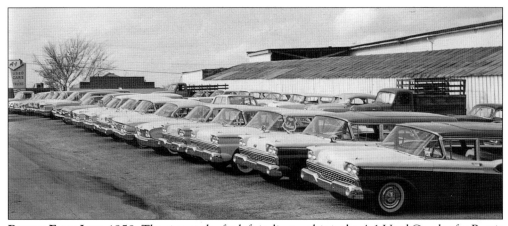

BURRIS FORD LOT, 1958. The sign at the far left indicates this is the A-1 Used Cars lot for Burris Ford. The lot is still due north of Country Club Bank on North Independence Street. Burris sold the business to G.R. Milner, who eventually moved it to its present site on Highway 71.

BEULAH'S 71 RESTAURANT, 1961. Beulah Rice operated this restaurant from 1961 to 1969, specializing in steak, chicken, and seafood as well as giant tenderloin sandwiches and homemade crescent rolls and pies. Rice bought fresh eggs and chickens from local farmers and had her restaurant open 24 hours a day, seven days a week. It was located at what is now the junction of Highways 71 and 291 at North Commercial Street. (Courtesy of Carol Bohl.)

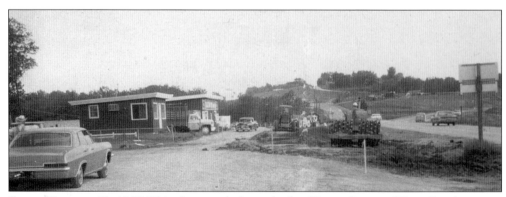

SOUTH HIGHWAY 71, 1965. This photograph shows the first Tractor Parts and Farm Supply store at its grand opening on April 20, 1965. Vernon Walker and Clair Sauter were partners until 1977, when Walker became the sole owner. Walker also operated a real estate agency and developed the land due east into a residential area, naming the streets after his children. (Courtesy of Bill Mills.)

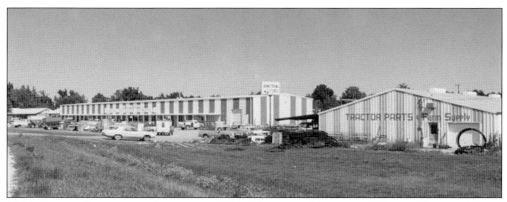

2301 SOUTH COMMERCIAL STREET, C. 1974. The second location of Tractor Parts and Farm Supply was this blue-and-white building just east of the original building. The grand opening was in August 1972. The name and logo were changed to the Family Center in January 1981.

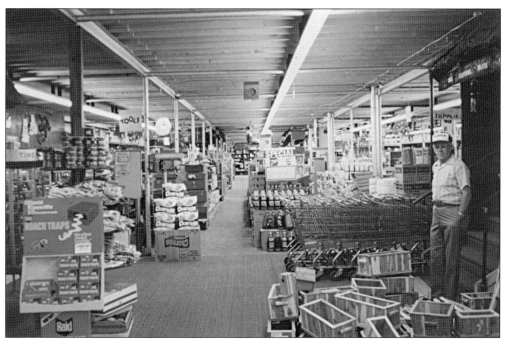

2301 SOUTH COMMERCIAL STREET, SEPTEMBER 1982. This is an interior shot of the merchandise on the first floor of Family Center in 1982. By this time, the company had expanded with a store in Versailles, Missouri. It added outlets in Farmington in 1984, Rolla in 1990, and later in Paola, Kansas, and Butler, Missouri. The Harrisonville store moved to Mill Walk Mall in 1985. (Courtesy of Bill Mills.)

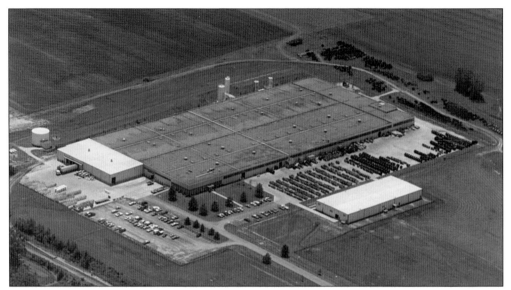

ANACONDA PLANT, 1983. Anaconda Wire and Cable Company arrived in Harrisonville in 1963 and established a plant on the southwest side of town. By 1983, the buildings covered 300,000 square feet and were managed by Anaconda Ericsson. Its copper wire and fiber-optic cables were shipped worldwide. It closed in 1987. The plant is now owned by Dwight and Church and produces sanitation agents. (Courtesy of Wendell Yeager.)

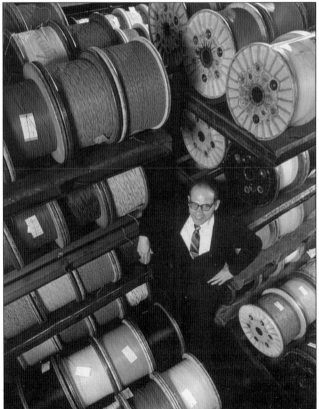

ANACONDA PLANT MANAGER, 1967–1977. Wendell Yeager stands amidst the variety of cables manufactured at the plant, including twin pairs and single conductors. Cables could be made of up to 3,600 pairs of 24-gauge insulated wires shipped on eight-foot steel reels. Such cables were used extensively in Vietnam during the war and to wire Las Vegas casinos, among their other uses. (Courtesy of Wendell Yeager.)

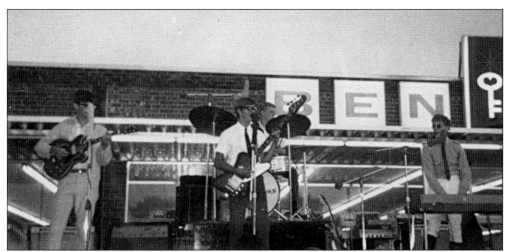

SOUTHLAND SHOPPING CENTER, AUGUST 1967. The Electrons provided music for a dance celebrating the grand opening of Southland Shopping Center. One of the stores was Ben Franklin, which had moved from the square to this site. Seen here, from left to right, are Marty Foster, Gary Ferrou, Jimmy McClain (drums), and Mike Peak (keyboard). Other local bands in the 1960s included the Scorpions, the Redcoats, and King James Version. (Courtesy of Mike Peak.)

OAKS MOBILE HOME COURT, 1970. In 1965, Dan and Harlan Davis developed The Oaks on land that was previously part of their Tourist Park on South Commercial Street, putting in pads for 65 homes. A horseshoe lake wraps around the west end. Ed Bohl bought it in 1977, and in 1993, he added 30 pads on the northern part of the 40 acres. The double lanes of Highway 71 lie west of the court.

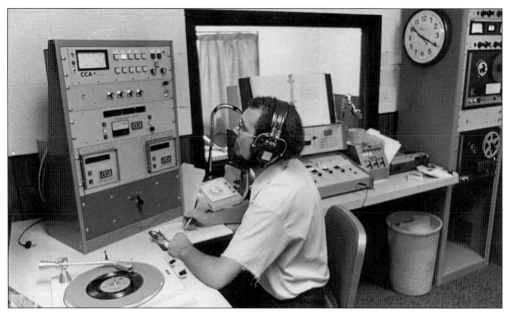

207 East Pearl Street, 1976. "Big Jim" Mitchell runs the board at station KIEE, 100.7 FM, which operated under the ownership of Arnie and Verla Wilson from 1975 until its sale in the early 1980s. It covered local news, sports, and events. Other employees included Darrell Zook, Ed Bohl, Rick Bien, and Marge Ball.

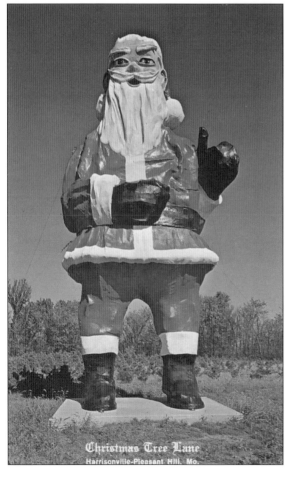

Christmas Tree Lane Santa, 1980. Many Harrisonville residents have fond memories of a trip to Christmas Tree Lane to search for the perfect tree, enjoy hot chocolate, and take a hayride. Oscar and Genie Urquhart began the operation in 1961 on their family farm northeast of Harrisonville. This 30-foot fiberglass Santa welcomed visitors. The farm closed in 1999. Santa later was moved to Harrisonville, where vandals destroyed it.

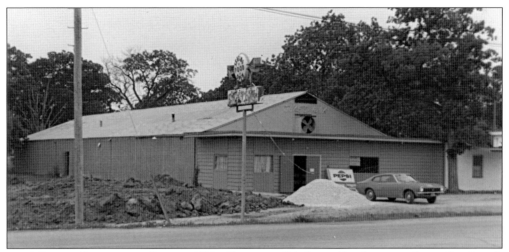

1202 SOUTH COMMERCIAL STREET, 1979. Harrisonville's first roller-skating rink was Gray's rink at this site. It was a wood building with sides that flipped up. Just east of the old rink, Gerald Morris constructed this metal building in 1954, which he and his son Duke operated. Ed and Carol Bohl purchased it in 1979, extensively remodeling it and updating the facility, even adding a fitness and racquetball center. (Courtesy of Carol Bohl.)

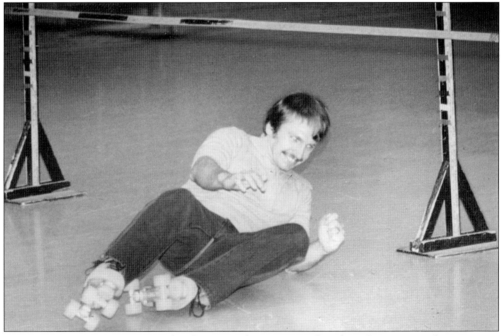

SKATING RINK LIMBO, 1984. The skating rink was a popular place for groups to host parties. Here, Jay Rugg, an employee of the Family Center, slides under the limbo bar. Many youngsters remember the limbo, snowball, birthday parties, and good times at the rink. In 1997, the structure was converted into the west campus of Harrisonville Christian School and the youth activity center for Harrisonville Community Church. (Courtesy of Bill Mills.)

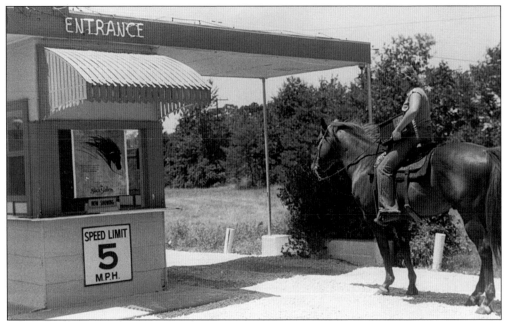

LEE DRIVE-IN THEATER, 1980. Holly Atkinson rode her horse, Gambler, to the open-air theater and brought along her transistor radio to hear the movies *Black Stallion* and *International Velvet*. The theater was built in 1950 and closed in the 1990s. It was located where the South Garden Apartments are today.

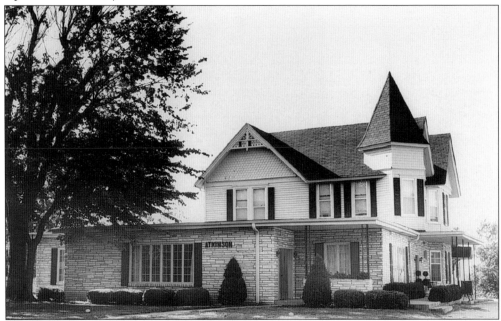

600 WEST WALL STREET, EARLY 1960s. Atkinson Funeral Home used the former home of George Bird as part of its complex. This photograph shows the first remodel. Brothers Floyd and Roy Atkinson and Clarence Easterla established the firm in Archie in 1927. In March 1933, they added a funeral home and chapel on the east side of the Harrisonville Square, which soon moved to the West Wall Street site it remains at today.

Four

COMMUNITY LIFE

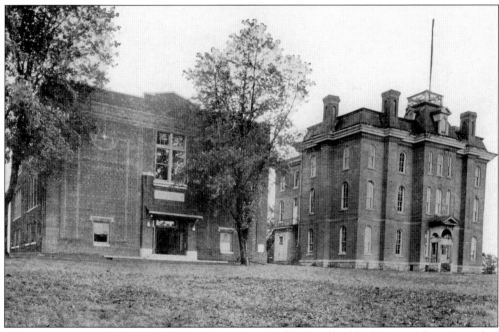

HARRISONVILLE SCHOOLS, 1920. The elementary and high school buildings at the east end of East Washington Street housed all area students for years. The high school (right) was built in 1872 to house all grades, while the elementary building (left) was completed in 1914. The old high school was razed in 1925 for a replacement, which in turn was razed to make way for today's middle school.

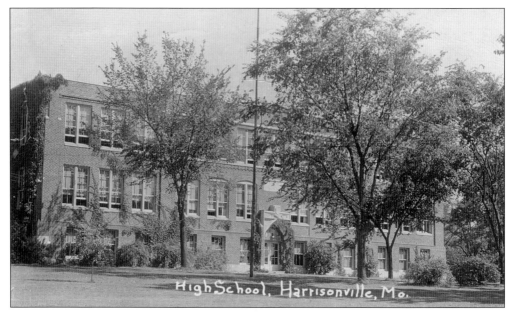

HARRISONVILLE HIGH SCHOOL, BUILT 1925. This three-story brick building replaced the original 1872 Harrisonville School at the east end of Washington Street. This structure cost $56,625. It served as the high school from 1925 to 1970 and the junior high school from 1970 to 1993, when the present middle school was built on this site.

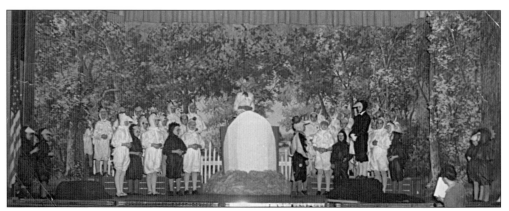

ELEMENTARY MUSICAL, 1948. School music programs have always been staples of the educational experience in Harrisonville. This cast performs *The Early Bird Catches the Worm*. All costumes were handmade by families. Carol and Sam Prettyman wear chicken costumes made by their mother, Clara Belle Prettyman. (Courtesy of Carol Prettyman.)

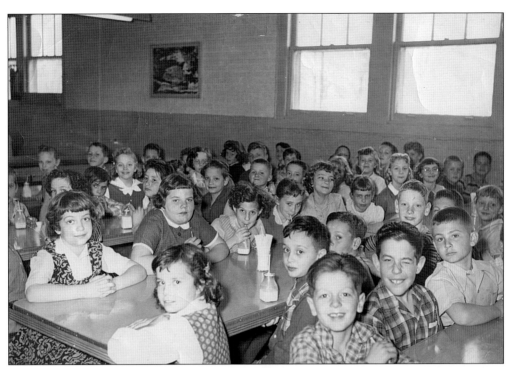

HARRISONVILLE GRADE SCHOOL, 1958. Students from this era will recall the milk break in the cafeteria. Note the small glass bottles and straws in the above image. (Courtesy of Jean Snider.)

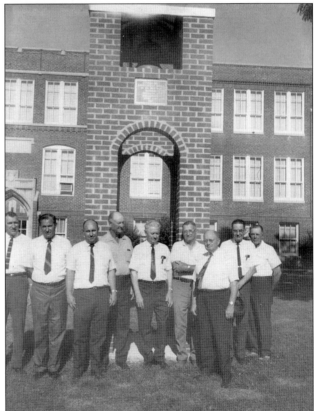

BELL TOWER, 1969. The bell tower at the middle school was a Harrisonville Lions Club project. The bell from the original 1872 town school was used until 1954. John Foster helped design the tower and Glennwood Davis did the brickwork. Seen here, from left to right, are Gene Olson, Bob Atkinson, new superintendent Walter Bruens, Fred Hellwig, Walter Heid, Bob Worthley, just-retired superintendent D.W. McEowen, Chester Long, and Jim Foreaker.

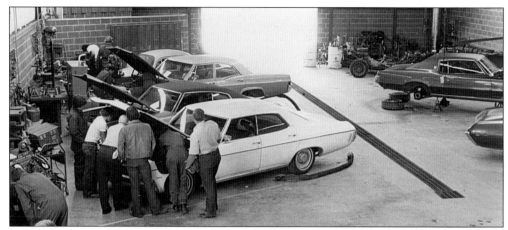

VOCATIONAL AND TECHNICAL SCHOOL, 1975. The new Cass County Area Vocational and Technical School was dedicated in October 1975. The 39,607-square-foot building, with a 550-student capacity, sits at 1600 Elm Street, north of the high school. It offered a wide array of business and technical classes such as the popular Auto Mechanics course seen here.

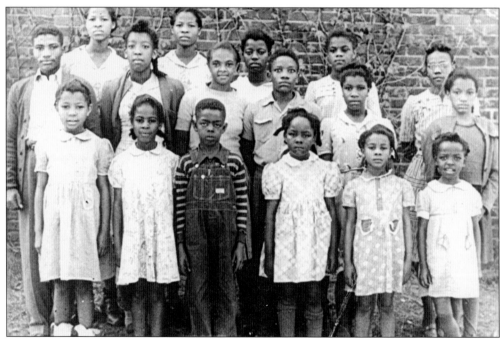

PRINCE WHIPPLE SCHOOL, 1941. This building remains at 902 East Elm Street. From left to right are (first row) Rosetta Jackson, Josephine Graham, Bill Allen, Bertha Jane Allen, Amanda Graham, and Priscilla Allen; (second row) Paul Graham, Barbara Handy, Nadine MacGruder, Froman Graham, Beatrice Graham, and LaVerna Green; (third row) Mary Stuart, Mattie Stuart, Delores Allen, Helen MacGruder, and teacher Mrs. Green. The schools were integrated in 1954 following the *Brown vs. Board of Education* Supreme Court ruling.

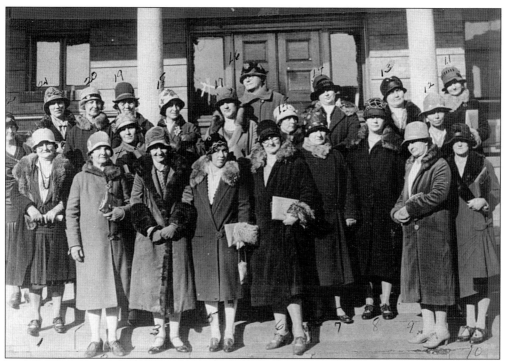

COUNCIL OF FARM WOMEN, 1928. Fifteen women's extension clubs were represented at the organizational meeting of the Cass County Council of Farm Women in Harrisonville on December 6, 1928. Their goals included helping to provide the best physical, mental, and spiritual development for farm families. They have the distinction of being the first such council in the State of Missouri.

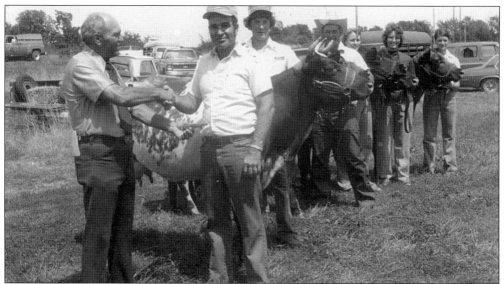

JUNIOR LIVESTOCK AUCTION, 1977. Vernon Winkler (left) of Allen Bank presents a cash prize for the best five dairy cattle to Charles Moreland. In the background are members of the Ed Friedrich family. This was the 28th-annual Cass County Junior Livestock Show and Second Annual Auction, held at North Park. A total of 45 FFA and 4-H members showed some 100 animals.

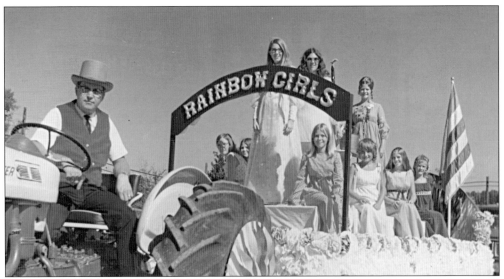

RAINBOW GIRLS FLOAT, SEPTEMBER 1971. The International Order of the Rainbow for Girls (IORG) is a Masonic youth service organization that teaches leadership training through community service. These members entered this float in the 1971 Labor Day Appreciation Day parade and celebration, capturing second place. This was the third year of the event, which was sponsored by Harrisonville merchants and professionals.

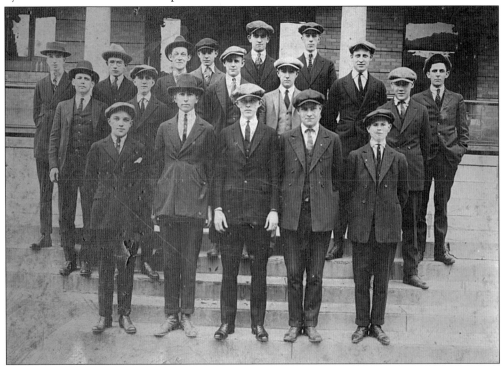

DEMOLAYS, C. 1920. Demolay is part of the Masonic family for young men ages 12 to 21. Harrisonville members at the time included, from left to right, Ernest Runnenburger, Urlyss Clatworthy, Forrest Ott, Lyle Kennedy, and Andrew Deacon. The group poses on the south steps of the courthouse on the square.

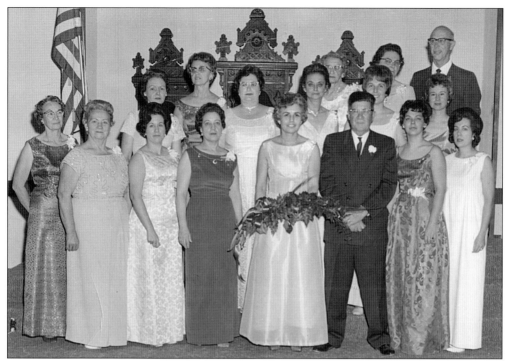

ORDER OF EASTERN STAR, 1967. The female companion to the Masons, this group was active for decades. The Bayard Chapter officers were, from left to right, (first row) Eleanor Dudley, Wilma Frances, Betty Fay Noland, Gertrude Davis, Ellen Wray, Kenneth Long, Lois Jean Hipple, and Mary Kay Danforth; (second row) Charlotte Toby, Glen Etta Stone, Marjorie Preston, Lela McGowan, Jessee Penington, Peggy Clum, Dolly Freeman, Carol Prettyman, and Bill Stone.

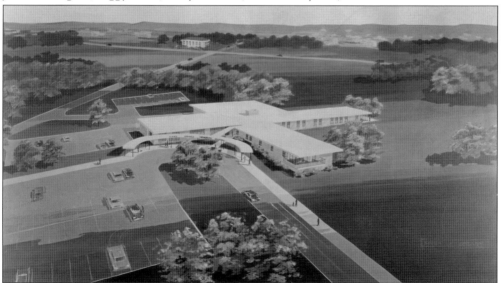

CASS COUNTY MEMORIAL HOSPITAL, 1963. This artist's concept of the 50-bed hospital built on the east side of town at 1800 East Mechanic Street indicates that there was no school or commercial development in the area at the time. The hospital was founded in 1946 at 104 West Pearl Street. The hospital moved from East Mechanic Street to its present site on Rock Haven Road in 2008.

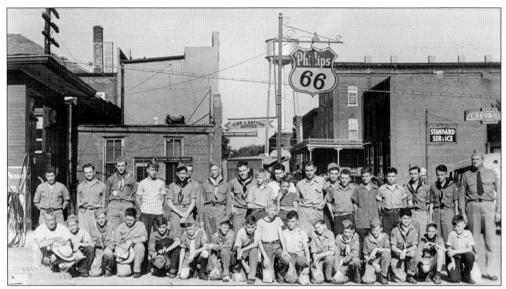

BOY SCOUTS, AUGUST 1, 1945. Harrisonville Boy Scouts and leaders gathered on East Pearl Street to head out to Scout camp near Osceola. Harry Reeder (first row, far left), operated a shoe repair shop on the square and was a dedicated Scout leader. Camp Reeder in City Park is named in his honor. His son, John Reeder, is third from the left in the second row.

CUB SCOUTS, C. 1950. Scouting was popular with boys growing up in Harrisonville in the mid-1900s. Younger boys started as Cub Scouts in groups like Den 240, seen here, working on models of a log cabin under the supervision of leader Barbara Powell on the right. Herbie Ray Carter, Kirk Powell, and Ronnie Bell were among this group.

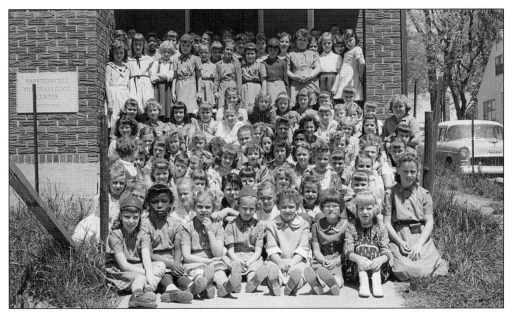

BROWNIE TROOPS, 1958. Girl Scouts were divided into age levels at the time of this photograph. Girls could join the Brownies for ages seven to nine and wore brown beanies and dresses. Meetings were held at the Youth Building on East Wall Street seen here. (Courtesy of Jean Snider.)

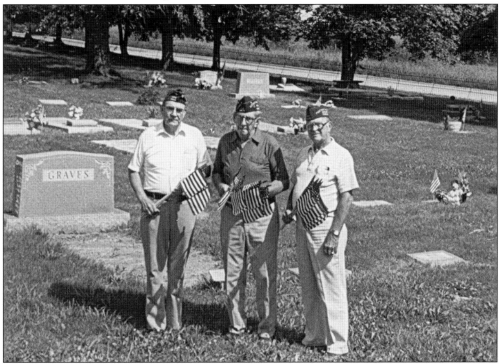

MEMORIAL DAY OBSERVANCE, MAY 1985. Three members of VFW Post 4409 mark the graves of veterans at Orient Cemetery. From left to right are Howard VanMeter, post commander from 1953 to 1954; Bob Ferguson, post commander from 1952 to 1953; and Bob Wallace, post commander from 1954 to 1955. The post still carries on this tradition.

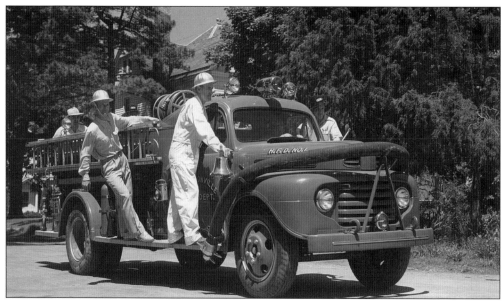

VOLUNTEER FIREMEN, C. 1960. Members of the Hurley Lee Spicer Post No. 42 American Legion Fire Department go through drills. A fire bell on the square called many local businessmen to the trucks housed around the square. Harvey Van Meter is at the back, W.R. Marquette is on the passenger side, and G.M. Allen is on the driver side.

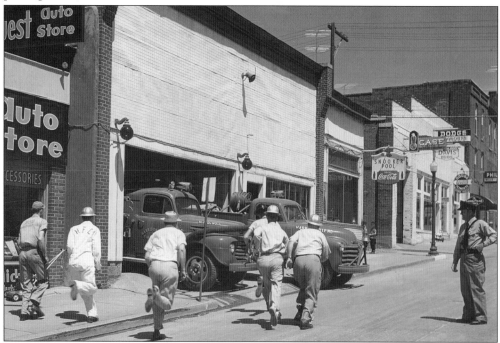

302 SOUTH INDEPENDENCE STREET, 1960. The nation's first volunteer American Legion Fire Department was established in Harrisonville in 1923 by the Hurley Lee Spicer Post No. 42. This photograph shows deputy John Stephens directing traffic during a fire drill in front of the fire station and city hall. Businesses up the hill included the Snooker & Pool Hall and the Davis Bros. Case, Plymouth, and Buick dealership.

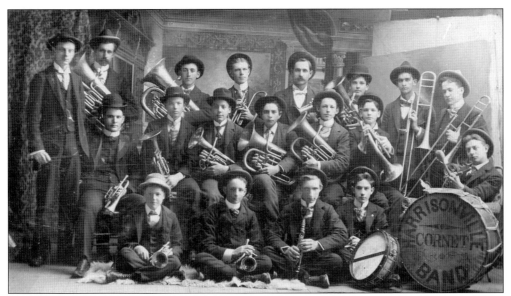

HARRISONVILLE CORNET BAND, 1898. Director John White led a Harrisonville brass band for over three decades. Members included, from left to right, (first row) Herbert Volle, John Urton Jr., L.O. Kunze Jr., and Hershel Hackler; (second row) George Corrigan, Fred Smith, Willard Skidmore, Walter Reece, Will Daniel, Mark Skidmore, and Harvey May; (third row) director John L. White, Charles Williams, Chester Thomas, John May, George Johnson, Frank Skidmore, Paul Doron, and Dell K. Hall.

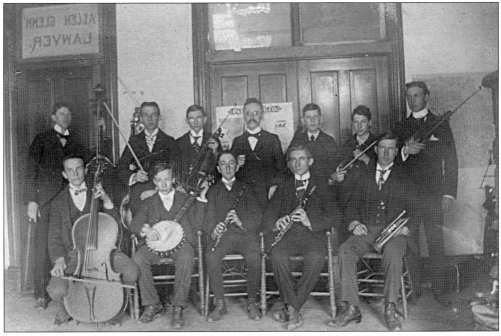

PROFESSOR DOGGETT, C. 1900. William Doggett (1859–1931) was blinded by scarlet fever. He arrived in Harrisonville in 1878 and taught all instruments. For years, he took the train to Peculiar and tapped his way from the depot to meet students. Here, he is with the Harrisonville orchestra in the law office of Allen Glenn on the second floor of a building on the east side of the square.

COMMUNITY BAND, JULY 4, 1976. This community band, under the direction of high school band director Herb Correll, marched in the bicentennial parade. The volunteer group included mostly high school students and some senior citizens. The group also performed a free concert in Harrisonville City Park on July 1.

SCHNELL GUN CLUB, C. 1940. Duck hunters still frequent the excellent waterfowl habitat near the Grand River south of Harrisonville. This group of Harrisonville residents evidently had success. Seen here are, from left to right, "Happy" Joe Salinger, Bob Brown (the cook), Thornton Byram, J.T. Willis, Judge Leslie Bruce, and Roy Denham.

VFW Auxiliary Bowling Team, 1959. Bowling leagues exploded in popularity in the 1950s. Named the Alley Cats, this team represented the local VFW Auxiliary 4409, the ladies' arm of the veterans group. Seen here are, from left to right (first row) captain Dorothy Poindexter; (second row) Connie Knox and Marjorie McClain; (third row) Kathleen Dickerson, Betty Welch, and Aldeen Ferguson.

Way Off Broadway Players, 1987. A group of local citizens organized in 1980 as a community theater group and staged a variety of plays for several years at various venues in Harrisonville. Shown in the production of Neil Simon's *Brighton Beach Memoirs* are Todd Schnacke, as the son; Norm Geyer, as the father; Kristin Hacker, as the daughter; and Gwen Fulton and Jan Bonnett as sisters. Mike Beahm was the director.

204 West Wall Street, c. 1962. The Cass County Library Headquarters and Harrisonville Branch were housed in the building at 200 West Wall Street from 1954 to 1962. In June 1962, it moved to 204 West Wall Street, to a building with 1,000 more square feet. A new building at 400 Oriole Street was completed in 1969, where the library was housed until it moved to the Information Center in 1984.

Harrisonville Branch Story Time, 1947. The first story time at the newly organized Cass County Library took place on December 20, 1947. The library was located at the back of Hotel Harrisonville, in the basement. Leading the group is the first head librarian, Dorthea Hyle. The library moved to West Wall Street, Oriole Street, and finally to its current site at 400 East Mechanic Street.

504 West Wall Street, Baptist Church. The First Baptist Church structure served the congregation from 1888 to 1963. The church was first organized as Hopewell Church in 1835, about two miles southwest of Harrisonville. In 1844, the church was moved to the lot in town where the present structure sits.

Harrisonville Mennonite Church, 1981. The congregation pulled together to break ground for the third addition to the church on Highway 2. Pastor Cleon Nyce uses a plow belonging to Dale Hershberger's grandfather, Dan, a Gunn City pioneer. Taking a photograph for the newspaper was editor Larry Pfautsch. The church is now known as Harrisonville Community Church. (Courtesy of Noel Floyd.)

400 SOUTH INDEPENDENCE STREET, 1908. This wooden structure was built for the First Christian Church (Disciples of Christ) congregation in 1882. The church was organized in 1856, and its first building at this site served as a Union cavalry stable and hospital during the Civil War. This second building was 30 feet by 60 feet and cost $3,500 but was destroyed by fire in 1916 and replaced with the present structure.

CHRISTIAN CHURCH, AUGUST 1965. Construction begins on the education building on the west end of the First Christian Church. The cost was $66,000, and the building committee was chaired by Bryan Fitzgerald. It was dedicated on March 16, 1967. Additional properties to the west were purchased in 1972 and 1984 to provide parking.

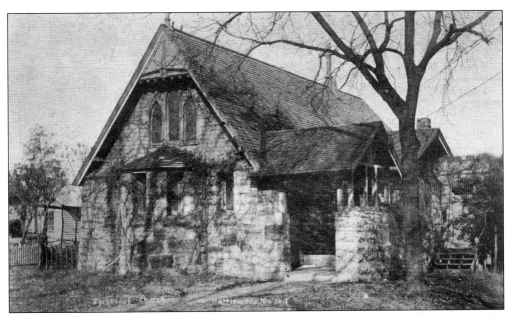

400 West Wall Street, Episcopal Church. St. Peters Episcopal Church was organized in 1871. Members met at various places until this structure was built and consecrated in 1899. The 25 leaded stained glass Tiffany windows were a gift from Bishop Spencer of the old Trinity Church of Kansas City. It was designed in the Gothic cruciform style by Arthur Jones of Kansas City and is on the National Register of Historic Places.

806 East Pine Street. Berea Church of God in Christ worships in this building, which was erected in 1949 under the pastorship of Rev. Joseph Lenley. It has served the African American community since that time. Note on the right, one block north at the corner of East Elm Street and North King Avenue is the building that served as the Prince Whipple School from 1916 to its closing in 1954, when the schools were integrated.

500 East Pearl Street, c. 1920. This building was constructed in 1878 by the Methodist Episcopal Church, which later became United Methodist Church. It was taken down and replaced with the present structure in 1930. The Methodists built a new building on North Highway 7 and moved there in 1986. The building at this site now serves the Grace Baptist Church community.

Agricultural Leaders, July 4, 1976. Leaders of the agricultural community were honored as part of Harrisonville's American Bicentennial parade. From left to right are Helen Morse, home economist; Gene Olson, balanced farming agent; Jay Moreland, local farmer; and centennial farm owners. Centennial farms must have a minimum of 40 acres used for farming in the same family for 100 years.

WALTER AND ELSIE RUSSELL, 1955. Cass County's new recorder of deeds, Walter Russell, poses with wife, Elsie, in the recorders office in the northeast corner of the 1897 courthouse on the square. (Courtesy of Doris Anstine Russell.)

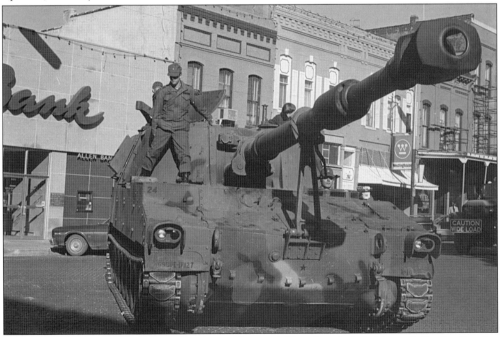

VETERANS' DAY PARADE, 1979. The Army National Guard included this tank for the Sunday parade in November 1979. Speakers included State Representative G.M. Allen and George Sweitzer Jr. Ray Stewart laid a wreath at the World War I Doughboy Memorial, just as he had done at the 1929 dedication 50 years before.

GENE OLSON RETIREMENT, 1983. On a Sunday afternoon in February, 300 people turned out to honor Gene and Bonnie Olson. Gene retired after a 33-year career in extension as a farm management specialist. Enough money was donated to purchase a pickup truck as a gift. Olson went on to represent the area as a state representative from 1986 to 1994.

YOUTH BUILDING, EAST WALL STREET. The masonry work on this building was done by Jake and Glenwood Davis. Funds were raised by local donations and the building was completed in 1950. It has hosted numerous civic and youth groups through the years.

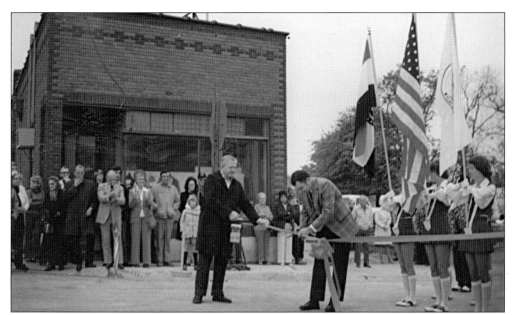

SOUTH INDEPENDENCE AND MECHANIC STREETS, OCTOBER 1977. Bob Smith cuts the ribbon to reopen South Independence Street following five months of construction. The high school band played "The Star-Spangled Banner," and Mayor Bob Johnson provided remarks. Note the lumberyard building in the back, which no longer stands. It was directly east of the Christian Church.

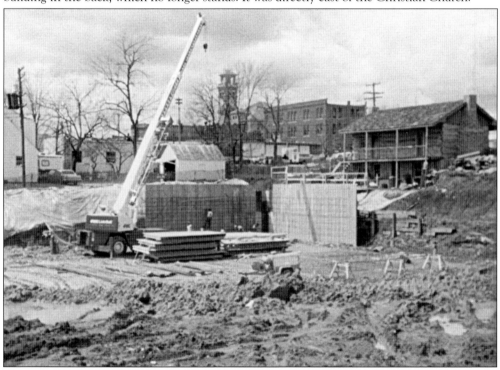

400 EAST MECHANIC STREET, APRIL 1984. The Cass County Historical Society, Cass County Public Library, and Harrisonville Chamber of Commerce partnered to finance the construction of the Information Center in 1984. The 26,562-square-foot structure was completed in 1985.

Log Cabin Tour, 1978. Jean Atkinson demonstrates cooking and life in the Sharp-Hopper Log Cabin for a visiting class. The cabin, originally built in 1835, survived the devastation of Order No. 11 during the Civil War in 1863. It originally sat about three miles northeast of Harrisonville and was moved to this site at 400 East Mechanic Street in 1974.

Irene Webster, 1981. Community leader Irene Webster was surprised with a "This Is Your Life" tribute for her substantial work bettering the Harrisonville community. John Foster, another outstanding community booster, acted as master of ceremonies. Webster led the Harrisonville Chamber of Commerce and Cass County Historical Society and was active with United Funds, BPW, the Red Cross, the Hospital Auxiliary, the VFW, and other groups. She married Paul Pippitt in 1998, at age 91.

Five

FUN AND GAMES

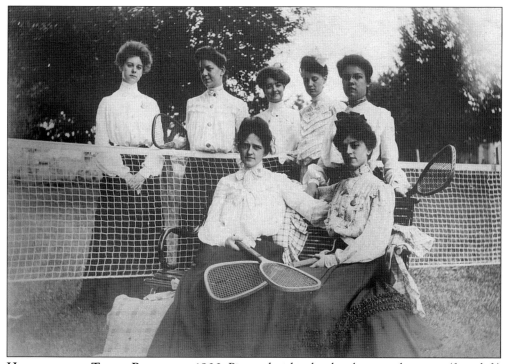

HARRISONVILLE TENNIS PLAYERS, C. 1900. Pictured with other local tennis players are (front left) Josephine Wirt and (second row, far left) Bernice Wilson. It must have been difficult to move around the court in such constrictive clothing.

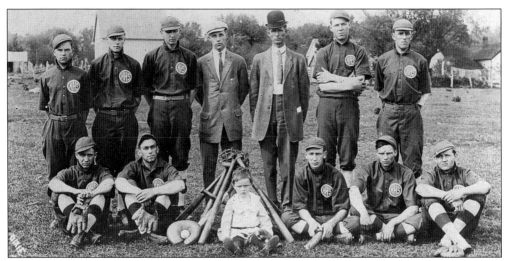

HIGH SCHOOL BASEBALL TEAM, 1912. Taken at Logan Park, this photograph shows the baseball team, wearing dark blue uniforms with a white "HHS" in a circle and white stockings with a blue stripe. From left to right are (first row) Charles Baston, Don Wright, mascot Charles Burke, Emmett Elder, Hurley Spicer, and Paul Hamilton; (second row) Everett Hughes, Ross Wright, Claude Owens, Clark Ewing, coach and superintendent C. Burke, Earl Parks, and Glenn Hamilton.

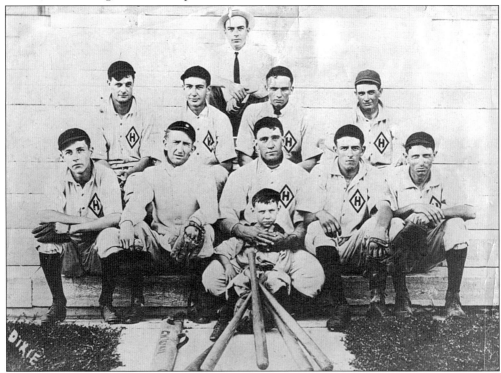

HIGH SCHOOL BASEBALL TEAM, 1910. Baseball was popular as early as the 1880s, as town teams competed against each other. This photograph, taken on the south steps of the Cass County Courthouse, includes batboy Billie Bradley, in front. From left to right are (first row) Clark Ewing, Charles Lewman, Dell Dutro, Glenn Hamilton, and Don Kennedy; (second row) Ben Edwards, Emmett Elder, Hurley Spicer, and Otis Martin. Team manager M.E. Halcomb is in the back.

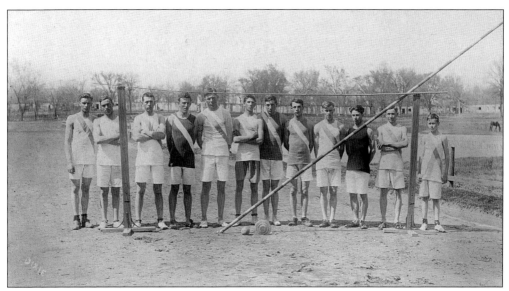

HIGH SCHOOL TRACK TEAM, 1914. This team won the Warrensburg meet the first time it ever competed there, with five firsts and two seconds. This photograph, taken at Harrisonville's old fairgrounds, includes, from left to right, Hurley Spicer, Don Wright, unidentified, Glen Hamilton, Earl Parks, Oren Webster, Galen Stark, Clark Ewing, Ross Wright, Ewing Brierly, Charles Baston, and Jay Brierly.

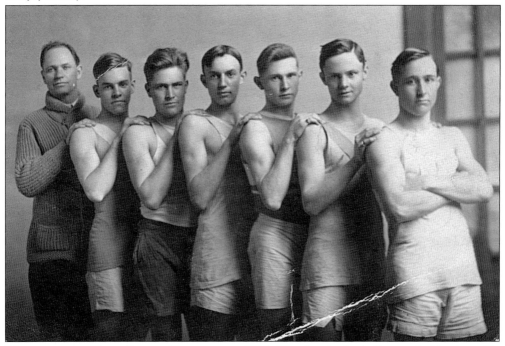

HARRISONVILLE HIGH SCHOOL BASKETBALL, 1915. The first basketball game in Harrisonville was played in 1899 by town teams from Harrisonville and Pleasant Hill, in Barrett's Hall on the square. The game was still evolving in 1915, which was the first year the dribbler could shoot, and there were still jump balls after every basket. From left to right are Professor List, Joel Ewing, Bert Wise, Brutus Hamilton, Fred Faverner, Givin Harger, and Clinton Gray.

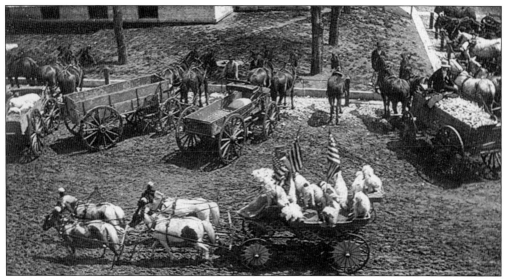

Circus Parade, c. 1900. Citizens of all ages eagerly awaited the arrival of the circus in town. The big parade, shown on the west side of the square, featured the acts delighting spectators under the big tent. The dogs on the wagon and the ponies pulling them were trained to perform as the original "Dog and Pony Show."

County Fairgrounds, 1912. In 1912, the fairgrounds lay west of the Harrisonville city limits near what is now close to Sutherlands. The Cass County Fair was established in 1896. Sitting in the grandstand for a good view are Tom Bird, Robert Glenn, and Harry Denham. (Courtesy of Allen Bird.)

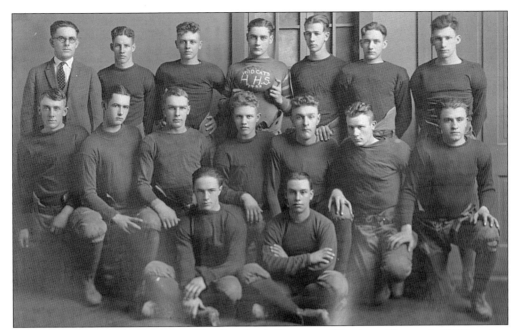

WILDCAT FOOTBALL TEAM, 1924. The first football game in Harrisonville was in 1896 against Lee's Summit's Pig Skin Gladiators. Harrisonville High School played its first game in 1906. Here, from left to right, are (first row) Joe Hall and Sam Stewart; (second row) Wayne Burch, "Eck" Wooldridge, Burton Moore, Dale Ament, Larry Lilliland, Claude Pickell, and Lewis Potts; (third row) Coach Drake, Sid Brous, Charles Williams, Ross Shelton, "Doc" Elder, Hallie Long, and Ed Webster.

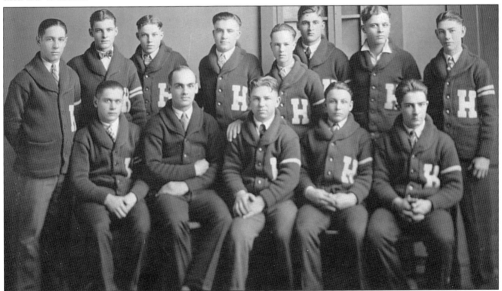

WILDCATS FOOTBALL TEAM, 1925. This team beat Butler, Appleton City, and Pleasant Hill but lost to Independence, Warrensburg, and Lee's Summit. The team included, from left to right, (first row) Robert Lewis, coach J.W. Reid Jr., Johnny Schmidt, H.C. Daniels Jr., Gilbert Holloway, and Willie Sulser; (second row) Robert Kershaw, Jim Prater, Harry Brown, Lewis Potts, Joe Miller, Charles Williams, and Foster Wiley. (Courtesy of Carol Prettyman.)

TRACK TEAM, 1932. At the Mid-West Conference Championships, Ernest Dunkin broke the state javelin record. Seen here, from left to right, are (first row) Howard Pearce, who was second in the state at the pole vault and was a middle distance runner; Leonard Bearce, discus and shot put; Gerald Gray, 880-meter and relay runner; and John Garten, dashes; (second row) Wesley Nichols, second in the state 880-meter and relay; Ernest Dunkin, javelin, shot, hurdles, high jump, and relays; George Brock, coach; and Bill Epps, dashes and relays.

BRUTUS KERR HAMILTON, 1922. Representing Harrisonville at the 1918 Missouri High School Championships, Hamilton won the high jump, pole vault, broad jump, and shot put. At the University of Missouri, he won the 1920 decathlon and pentathlon, which qualified him for the 1920 Summer Olympics in Antwerp, Belgium, where he captured second place in the decathlon, missing out on the gold medal by only four points. (Courtesy of *Missouri University Savatar*, 1922.)

ADVERTISEMENT, 1934. The horse show arena in Davis Brothers Park hosted popular shows for decades. Animals were housed in barns, which were later used for the Cass County Junior Livestock Show in the 1950s. The shelters were dismantled and auctioned off in the 1960s to raise money to build the present structures at North Park.

5th Annual
HARRISONVILLE
HORSE SHOW

DAVIS BROS. PARK
On U. S. Highway No. 71 at Harrisonville, Mo.

Wednesday, Thursday, Friday
AUGUST 29, 30, 31
Show Begins Each Evening at 7;45 o'Clock

23 Classes
Three-Gaited Horses
Five-Gaited Horses
Roadsters

$601.50
IN PRIZES

250 Box Seats
$3 per box for season
4 chairs in each box

GENERAL ADMISSION
10c

Box seats now on sale at the P. K. Glenn Drug Store, Harrisonville. Reservations may be mailed--check must accompany order. For information, write to JAMES D. IDOL, Secretary, Harrisonville, Mo.

DAVIS BROTHERS PARK, 1930S. Tennis courts were just one of many attractions at the Davis Brothers Tourist and Amusement Park. Harlan and Dan Davis built it in 1929 on the new Highway 71, west of what is now South Commercial Street near Sonic. It featured a lighted swimming pool, mini golf, a baseball field, picnic grounds, a lake, tourist cabins, a lunchroom, a soda fountain, a dance pavilion, and a horse arena. (Courtesy of Mary Doris Davis.)

Russell Family Croquet, May 1939. The Tat Russell family lived on the outskirts of Harrisonville near Zion School. They often gathered on the lawn to play croquet and badminton with family and friends. These sports were popular ways of spending time together for area residents. (Courtesy of Doris Anstine Russell.)

Cass County Maid of Milk, 1956. Attendant Carol Sue Bailey rides past the northeast corner of the square in a car belonging to H.R. (Harry Robert III) Pearson. The dairy industry was an important economic engine in the county for decades in the mid-1900s. (Courtesy of Carol Bailey Price.)

WILDCATS FOOTBALL TEAM, 1951. The greatest team in Harrisonville's first 45 years of football went undefeated, capturing the Mid-West Conference and defeating Higginsville at the Mineral Water Bowl in Excelsior Springs. Co-captains Dudley Childress and Jerry Crisp were led by head coach Jay Anderson and assistant coach Luke Scavuzzo.

GIRLS' BASKETBALL, 1950–1951. The Harrisonville girls won 25 of 28 games in the 1950–1951 season. From left to right are (first row) Maxine Needs, Doris Cummings, Kathryn Carlson, Kay Walker, Joyce Evers, Carolyn Evers, and Virginia Hargus; (second row) teacher Mary Perdue, Dorothy Gauret, Doris Anstine, Donna Strate, Patty Witt, Mary Ann Childress, Wilma Carlile, Mary Ellen Needs, and coach Danny Bottero; (third row) Wanda Carlile, Jan Sehorn, Sue Marriott, and Sue Ann Walkup.

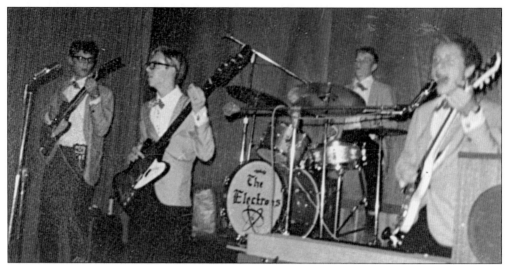

THE ELECTRONS, JUNE 1965. This popular Harrisonville group played at dances and events in the mid-1960s. Here, they perform at a dance at the Youth Building on East Wall Street. From left to right are Marty Foster, Gary Ferrou, drummer Jimmie McClain, and Mike Peak. (Courtesy of Mike Peak.)

DRUM AND BUGLE CORPS, 1970s. This Scouting group appeared in many events in the 1970s. They are seen here on the west side of the square during an Appreciation Day parade.

WORLD'S LARGEST TEAPOT, 1971. Andrew Kimmell of Harrisonville's Kimmell Engineering developed this Mod Tea Pot made of fiberglass and invented Kepoxy, which held 1,420 gallons of tea. He installed spigots to serve an estimated 5,000 people at the Labor Day Appreciation Days in City Park in September 1971.

BOWLING LEAGUE CHAMPS, 1975. Bowling for fun and competition thrived from the 1950s through the 1980s. This team included, from left to right Tat Russell, Melvin Doyle, Red Cunningham, Kenneth Higgs, and Travis Majors. (Courtesy of Doris Anstine Russell.)

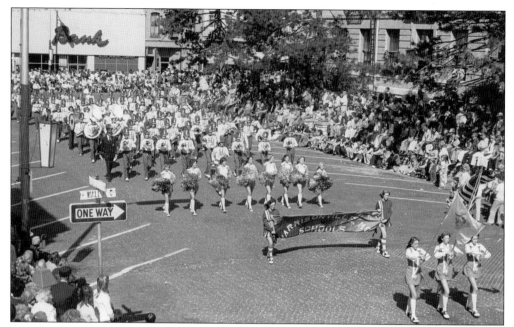

Log Cabin Festival Parade, 1978. Festival parades on Sunday afternoons were well over two hours long and attracted crowds of more than 10,000 along the route from the high school, on East Elm Street, east on Pearl Street and around the square. The festival was held on the first weekend in October from 1975 until 1997. This photograph shows the Harrisonville High School band on the west side of the square.

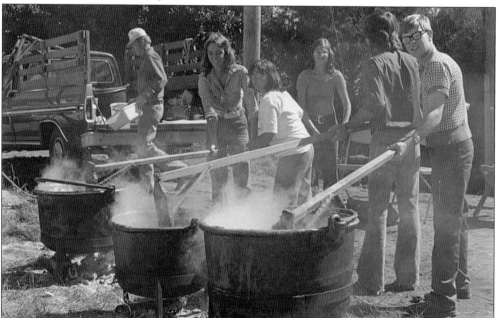

Log Cabin Festival, 1976. One of the main purposes of the festival was to honor and preserve the traditions of pioneer Cass County settlers. Local students worked together to stir the iron kettles cooking down apples for apple butter near the Sharp-Hopper Cabin. Other popular attractions were the craft tents and stage performances.

SHARP-HOPPER CABIN, 1974. The 1835 Sharp-Hopper Log Cabin was opened to the public for the first time in December 1974. The cabin was dismantled at its original site about 3.5 miles northwest of Harrisonville and carefully reconstructed by members of Cass County Historical Society as a commemoration of early pioneer heritage.

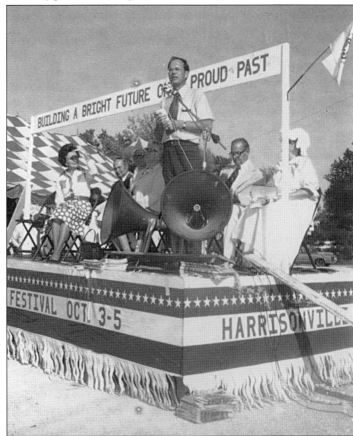

FIRST LOG CABIN FESTIVAL, 1975. Ed Bohl, the chairman of the first Log Cabin Festival committee, welcomes the public. Activities included an arts and crafts tent, apple butter making, old-fashioned contests of all kinds, a Saturday youth parade, a Sunday general parade, a historic homes tour, antique farm equipment displays, music, a melodrama, a flower show, and square-dancing, all to honor pioneer heritage.

Discover Thousands of Local History Books
Featuring Millions of Vintage Images

Arcadia Publishing, the leading local history publisher in the United States, is committed to making history accessible and meaningful through publishing books that celebrate and preserve the heritage of America's people and places.

Find more books like this at
www.arcadiapublishing.com

Search for your hometown history, your old stomping grounds, and even your favorite sports team.